General Editor
David Piper

Titian

The Complete Paintings I

Terisio Pignatti

Art History Department, University of Venice

Translated by Jane Carroll

GRANADA
London Toronto Sydney NewYork

Foreword by the General Editor

Several factors have made possible the phenomenal surge of interest in art in the twentieth century: notably the growth of museums, the increase of leisure, the speed and relative ease of modern travel, and not least the extraordinary expansion and refinement of techniques of reproduction of works of art, from the ubiquitous colour postcards, cheap popular books of colour plates, to film and television. A basic need – for the general art public, as for specialized students, academic libraries, the art trade – is for accessible, reliable, comprehensive accounts of the works of the individual great masters of painting; this has not been met since the demise before 1939 of the famous German series, *Klassiker der Kunst*; when such accounts do appear, in the shape of full *catalogues raisonnés*, they are vast in price as in size, and beyond the reach of most individual pockets and the capacity of most private bookshelves.

The aim of the present series is to provide an up-to-date equivalent of the *Klassiker* for the now enormously enlarged public interested in art. Each volume (or volumes, where the quantity of work to be reproduced cannot be contained in a single one) catalogues and illustrates chronologically the complete paintings of the artist concerned. The catalogues reflect as far as possible a consensus of current expert opinion about the status of each picture; in the nature of things, consensus has yet to be reached on many points, and no one professionally involved in the study of art-history would ever be so rash as to claim definitiveness. Within the bounds of human fallibility, however, every effort has been made to achieve both comprehensiveness and factual accuracy, while the quality of reproduction aimed at is the highest possible in this price range, and includes, of course, colour. Every effort has also been made to hold the price down to the lowest possible level, so that these volumes may stay within the reach not only of libraries, but of the individual student and lover of great painting, so that they may gradually accumulate their own 'Museum without Walls'. The introductions, written by acknowledged authorities, summarize the life and works of the artists, while the illustrations place in perspective the complete story of the development of each painter's genius through his career.

David Piper

Introduction

The castle of Pieve di Cadore, glimpsed between the dense pines and ilexes of the surrounding woodland, appears wild and forbidding to the visitor climbing up by the road from Venice. Behind, on the mountain slopes, houses huddle round the parish church and town hall. Even today a somewhat bellicose atmosphere hangs over the narrow, steep streets of the little town. Pieve preserves the character of a border stronghold: a fortress facing south, almost as though confronting the Republic of St Mark.

One of the oldest families of Cadore was the Vecellio family, whose records go back to 1398. It numbered among its members many lawyers, mayors, superintendents, militia captains, border stewards and ambassadors to the Republic and to the Empire. Its most famous member was Conte Vecellio who between 1458 and 1513, the year of his death, occupied all the main government positions at various times and was awarded all the major honours. His son, Gregorio, superintendent of grains and mines, also made his name as a valiant soldier defending the fortress of Pieve during the war of the League of Cambrai. His children, two sons and three daughters, probably stayed in Venice during this period. Breaking with family tradition the sons, Francesco, possibly the elder, and Titian, became not lawyers or soldiers, but painters.

Contemporary documents reveal very little information about the early life of the two boys. According to the well-informed Dolce (1557), Titian was probably in the care of a paternal uncle who was a notary in Venice. At the age of 9 or 10 he became a pupil of Sebastiano Zuccato, father of the future mosaic artists of St Mark's, Valerio and Francesco. Then (according to Vasari, 1568) he studied under Gentile and Giovanni

Bellini. Finally, he worked with Giorgione who in that period was making his name as a master of great originality.

Titian's age during this period of apprenticeship is not clear. Contradictions in various relevant documents and sources mean that we have no definite knowledge of his date of birth. However, three hypotheses are put forward: 1473, if we believe a note in the register of deaths in the parish of San Canciano, in which the priest states that on 27 August 1576 Titian 'died at the age of 103'; 1476–7, according to a letter dated 1 August 1571 to the king of Spain, Philip II, in which Titian said that he was 95 years old; and 1490, on the basis of direct evidence collected by Vasari who said Titian was 76 years old in 1566. The last date is confirmed by another statement by Vasari, that Titian was 'not more than 18' when he painted the Barbarigo portrait (No. 3) and by Dolce's assertion that the painter was 'just 20' when the frescoes on the Fondaco dei Tedeschi (German Warehouse, Nos. 2A–2L) were completed.

The present author considers that Titian gave false information about his age in the letter to Philip II, in order to arouse the king's pity. The legend about the artist's great age probably led to an incorrect record in the San Canciano register of deaths. The most accept able date is around 1490, not only because it is confirmed by many sources but, above all, because this date fits with the chronology of works known to us, whereas the others do not.

Whatever his date of birth, Titian was precocious. Dolce wrote of him approvingly: 'He was a painter even in his mother's womb.' But what has come down to us of his earliest works? The supposed 'early scrawls' painted on the walls of various houses in Pieve di

Cadore are unconvincing; nor are there any works in existence which show even a hint of the influence of the old-fashioned school of Zuccato. Moreover there is no trace of Titian's hand in any of Giovanni Bellini's paintings of the early sixteenth century (despite the attempt by some authorities to suggest intervention by Titian in the St John Chrysostom altarpiece completed by Bellini in 1513).

Once his apprenticeship was over, Titian first began to make a name for himself in about 1508 when he was still under 20 with the frescoes on the Fondaco dei Tedeschi. But not even in that work is it possible to trace any marked signs of influence from his masters, including Giorgione although he may have been working on the scaffolding only a few metres away. His work could have appeared similar to Titian's only to the most uneducated of Venetians. Nevertheless, according to Dolce, there were those who confused the work of the two men, an assessment which Giorgione regarded as a bitter insult. It was the painting *Judith* (No. 2A) which caused the confusion. If we compare this painting with Giorgione's *Nude* (the only surviving piece left from his stupendous façade) it is easy to recognize that the young artist was contending with his master, who was already a well-known artist. His Judith, brandishing a sword and trampling a bloody severed head underfoot, has a vigorous, dynamic pose; the line is well defined and the colour realistic, and a sensual effect is produced by uncovering just one shoulder. Giorgione, on the other hand, though depicting his figure entirely nude, seems to rely for sensual effect on an artificial chromatic exaggeration ('a great burst of flaming red', according to Zanetti, 1760). And Titian's *Battle between Monsters and Giants* (No. 2B) – also saved from the Fondaco – shows a spirit which is more Nordic than classical and one which was obviously inspired by engravings and other sources introduced with the new, wider European culture of the Cinquecento. The important recent view that Titian was influenced by such contact is now confirmed by the most recent authorities (Hetzer 1929; Pignatti 1974; Chastel 1978).

How far the development of the young Titian was affected by the presence of Albrecht Dürer, who was in Venice in 1505–6 to paint the *Madonna of the Rosary* in the Church of San Bartolomeo, can be guessed by examining his early works and a number of vigorous drawings made with pen-strokes which seem like cuts made with a burin or gouge. Moreover, Titian's sudden interest in landscape (the Padua pair of panels: Nos. 8–9) and in the nude (*Lucretia*; No. 5) seems to originate not so much in Giorgione as in lessons learned from Dürer. Certainly the latter must have inspired Titian's youthful masterpiece, the woodcut (dated by Vasari to 1508) of *The Triumph of Christ*. On the other hand, faint echoes of Bellini's *sacra conversazione* are noticeable in Titian's early works such as the Yale *Circumcision* (No. 6) or the Bergamo *Madonna* (No. 7). Nevertheless it is clear that Titian's human figures are sensual and physical, and that he communicates in a direct immediate manner which goes far beyond the still-stylized, traditional and humanistic forms of Bellini.

If Dürer was an important factor in the formation of Titian's artistic temperament, Giorgione's role in his development related above all to his iconography, particularly in landscape. In this respect his influence is present in the very early *Nativity* (Raleigh; No. 1), possibly the first known work by Titian. We find hints of Giorgione again in works of wide and mature concept such as the Leningrad *Flight into Egypt* (No. 14) and the Louvre *Pastoral Concert* (No. 15). It is true that the legacy of Giorgione steadily weakened, both with respect to themes and to the use of colours and the atmospheric blending of tones, but there remained in Titian's early works an echo of his master, a particular feeling which places them both within the same definite tradition. Titian, although not an imitator of Giorgione, showed himself to be sufficiently Giorgionesque in his early works to mislead art historians, even today. Even by the sixteenth and seventeenth centuries writers referred to the confusion which existed between Giorgione's last and Titian's early works. Today the pictures most disputed are the famous Louvre *Pastoral Concert* (No. 15), the Pitti Palace *Concert* (No. 20) and the *Portrait of a Knight of Malta* (No. 21), the last two of which are undoubtedly by Titian. This is particularly clear in the case of

the Pitti *Concert* since recent cleaning. Other disputed works are certainly by Giorgione, such as *Christ Bearing the Cross* at San Rocco (No. 628), the Venice *Old Woman*, the first version of the Vendramin *Christ* (No. 85) and the Dresden *Venus* (No. 547).

Where Titian stands out clearly from the Giorgionesque tradition is in his use of colour. Giorgione painted subtle layers of colour in short, curving brushstrokes, building up film upon film over an unsuppressable chiaroscuro even in places where, in Vasari's words, he painted 'without drawing'. What remains of this style in Titian's dense, gleaming, corporeal colours, seen for example in the Prado *Madonna and Child with SS Anthony of Padua and Roch* (No. 17) and the Vienna *Gipsy Madonna* (No. 18)? And what is the inner force which seems about to spring from the tense series of portraits from the Pitti Palace *Concert* to the Metropolitan (No. 24), Bordeaux (No. 22), Indianapolis (No. 23) and Pasadena (No. 25) 'gentlemen'? An uncontainable vitality, expressed by technical and formal means, rich in communicative potential and brimming over with emotion, seems to pervade all of Titian's youthful work. Perhaps a certain spirit of independence and liking for contradiction (what one might expect from a mountain-dweller) led Titian to regard certain Venetian paintings as rather weak, over-refined and bloodless, decadent and artificial.

The young artist may also have been troubled by the tragic events of the years between 1509 (the Republic's disastrous defeat at Agnadello) and 1513 (Venice bombarded and virtually besieged by the forces of the League of Cambrai). In these years Venice suffered the nightmare of the plague, which claimed so many lives, including that of Giorgione in 1510. Titian may well have been affected by the wave of fear that infected the city that the Republic had reached the end of its days. Terror also spread through the countryside which had experienced fire and sword at the hands of the Imperial troops, its defences crushed by the German mercenaries, its cities sacked and then reconquered (as had happened in the case of Padua) after bloody battles.

While heroic sentiments were reawakened in Venice, together with allied emotions of humility and penitence, Titian went to Padua, to seek serenity among the monks of Sant'Antonio. Here he created the Scuola di Sant'Antonio frescoes, the series of *Miracles of St Anthony*, patron saint of the city (Nos. 28A–28C). In these dramatic scenes Titian expresses a range of fierce emotions in unforgettable pictorial form.

Youthful enthusiasm is mixed in Titian's soul with deep anxiety, including the anguish he feels for the events which created havoc with the places and people he loved. But Titian emerges with a strengthened faith in man, man as a microcosm of universal order; man as seen in the holy wars he undertakes, in the Christian miracles, in the apparitions which exalt popular consciousness, in the myths of the past which provide refuge for the soul longing for a blessed Golden Age amidst so much trouble. So the images crowded onto the canvas and the young artist began to build up a reputation for himself among potential customers. He was virtually the only surviving artist of his generation: Bellini by now was very old, Giorgione was dead, Sebastiano Luciani had gone to Rome and Lorenzo Lotto had fled to the Marches.

When the plague ended in 1510, Titian painted the Santo Spirito altarpiece (No. 34). He gives his five saints a serene air; they appear to be in friendly conversation, yet the form is classically noble, the underlying sentiments are lofty and solemn, and the colours (coming back to life in the current cleaning) are resplendent. The figures in the '*Noli me tangere*', now in London (No. 35) are also magnificently serene, as are those in the Edinburgh *Three Ages* (No. 37); the plastic form is classical, and so is the colour, laid on richly, so that naturalistic imitation is transformed harmoniously into a song of praise to the beauty of creation. Titian's *sacra conversazione* has developed from the emblematic presentation typical of Bellini's tradition: his saints are cordial, men of the people (London *Holy Family*, No. 40 and the Marquis of Bath *Holy Family*, No. 38). His donors show lively emotions of devotion and faith (the Magnani No. 44, Ellesmere No. 41 (now in Edinburgh), and the Munich No. 43 *Madonnas*). In the latter paintings, perhaps partly because of the addition of a profane element – the donor – Titian's use of colour tends to a

more vivid incisiveness and the surfaces create the changing colour effects which were to characterize his style towards the middle of the 1520s.

Increasingly, Titian's success brought him into contact with the nobles of the city, and he became their favourite portrait painter. He knew how best to exploit the relative vacuum left by the departure of the best Giorgionesque painters – only Palma remained – and of the relative mediocrity of the followers of Bellini. With a skilful, open approach to his subject matter Titian, in posing his rich merchants and gentlemen, made use both of a traditional style (Copenhagen *Portrait of a Man*, No. 48) and of other, more innovative and revolutionary approaches (the London *Serving Woman*, No. 45 and the '*Ariosto*', No. 46). In Titian's latest work the reserved manner of Bellini, Giorgione's timidity and Palma's over-prosaic treatment are suddenly transformed: animated poses surprise with their naturalness, colour emphasizes unusual lights and draws attention to particular psychological details and iconographic motives. It can be claimed that Titian invented a new way to communicate by the use of what might be called a 'signal': the attention of the observer is caught by a detail – a hand, a cap, a silvered doublet, a classical bas-relief, a plunging neckline.

In the female portraits of the 1520s in particular, Titian created a model destined to endure beyond his age. Take, for example, the frontal and three-quarters placing of the two Vienna portraits of fair-haired women (Nos. 52–53), dressed respectively in black and in blue and gold. By comparison, the Doria *Salome* (No. 49) and the Louvre *Young Woman at her Toilet* (No. 50) seem tied to more archaic and traditional rhythms. Again we find creative invention at its height in certain 'fables' which are really portraits, such as the Vienna *Lucretia* (No. 54), a splendour of whites set off by emerald, the Uffizi *Flora* (No. 55), a dream from a lost Golden Age, and the Borghese *Sacred and Profane Love* (No. 56), painted for Chancellor Nicolo Aurelio, possibly around 1515.

This marvellous canvas reflects in a complex allegory (Celestial Love and Terrestrial Love, represented by twin Venuses) the sophisticated tastes of Aurelio, a cultivated man of advanced views. It also marks an important stage in Titian's own development. The classical allusions, underlined by the allegorical bas-relief on the sarcophagus, justify the otherwise somewhat gratuitous iconography; but Titian reveals in a complex image the spirit – of the Venetian High Renaissance – in the vitality and flowing natural lines of the two women, one naked and the other clothed, symbolically placed in opposition to one another yet emotionally united in their *joie de vivre*, in the suggestion of optimism, and of enjoyment of the senses and of human things.

As Titian's fame was spreading, Bellini, who until then had been the recognized patriarch of the Venetian painters, was growing older, and at the age of 23, the younger man was already sufficiently self-confident to be planning to replace the master. On 31 May 1513 he proposed to the Signoria that they commission a painting for the Sala del Maggior Consiglio, hitherto the uncontested domain of Bellini. The picture was the *Battle* (No. 171), 'which is the most difficult and which no man to this day has wanted to undertake'. In addition, he asked Bellini to cede to him the pension of 100 ducats (the Brokerage Office concession) which was payable to the palace painter. Naturally Bellini rejected this proposal but Titian, backed by powerful friends, who must have included Aurelio, obtained the commission to paint the *Battle* (although he did not hand it over until 25 years later) and put his own name down for the 'brokerage', which he eventually received three years later, after Bellini's death.

The next period in the artist's life involved numerous public commissions. It was as though he had emerged from the intimacy of his studio, arrogant and ambitious. Nevertheless he remained, on the whole, faithful to Venice and showed considerable reluctance to leave the city even when called to the most prestigious courts. In 1513 he refused an invitation from Pope Leo X, which had been brought by the poet Pietro Bembo. The enormous *Battle* canvas, which was already taking shape in Titian's mind, may have been one reason for his renouncing this opportunity. It is interesting to speculate what path his painting would have taken if he had gone

to Rome in that period and met Raphael and Michelangelo, of whom he had only indirect knowledge through the works of Marcantonio Raimondi, Fra Bartolomeo and othei travellers. From about 1515 Titian's ideas became more ambitious. The *Assumption* (No. 71), painted for the Frari church between 1516 and 1518, shows that his thoughts were not without a trace of Raphael's classical use of colour and Michelangelo's monumental constructivism. The huge panel was greeted as a triumph by all the best-known art connoisseurs who, like Sanudo, were now persuaded that Venice at last had a school of painting to rival that of papal Rome. The well-informed Lodovico Dolce was later to describe the work in these words: 'The greatness and *terribilità* of Michelangelo, the charm and beauty of Raphael, and the colours of nature itself.' The painting of the *Assumption* was another great achievement and Titian was now regarded as a painter who combined fresh ideas with traditional elements. The forceful perspective in which the apostles are drawn (they apparently gained him the reproaches of the timid Frate Germano who had commissioned the work) recalls Michelangelo, while the work also relates iconographically and in colour to Raphael's *Disputa* in the Vatican. But it is above all important to recognize the daring innovation Titian had made in 1516 in Venice, the city where Bellini's memory was still strong: he had broken away from a conservative tradition in which images were still presented frontally in a neo-Byzantine manner. Titian's images are alive with newly discovered emotions and casual movements which, even though they become part of an underlying design, stand out as vitally expressive pictorial forms. Pordenone, let us not forget, was working nearby, about to paint the frescoes in the Malchiostro Chapel in the Duomo at Treviso, where Titian also worked (No. 112). With characteristic intuition and in harmony with past tradition, he absorbed elements from the new, foreign influences (especially German) which were to become a recognizable part of Mannerist ideology.

In the years between the commissioning of the *Battle* in the Doge's Palace and completion of the *Assumption*, Titian also re-turned to portrait painting, this time preferring an intimate form of representation which concentrated on faces and expressions: (the Ajaccio *Portrait of a Young Man*, No. 58; the Halifax *Portrait*, No. 59; the Frick Collection *Young Man*, No. 57; the Spada Collection *Portrait*, No. 63; the Petworth House *Young Man*, No. 62). Sometimes he chose an unusual pose for his figure, for example the figure turns his back, as in the Munich *Portrait of a Young Man in a Fur* (No. 60) or in the Vienna *Bravo* (No. 61). In the Dresden *Tribute Money* (No. 64) he draws the figures out of dense shadow into the foreground, illuminating them very strongly. The red sleeve of the bravo and the balancing red and blue of the Christ are unforgettable. A similar use of colour – defined as 'chromatic classicism', to describe its combination of nobility and naturalism – underlines the beauty of the composition of two famous *sacra conversazione*: the Vienna *Madonna of the Cherries* (No. 68) and the Prado *Madonna with SS Ulfus and Bridget* (No. 69), both of which are as magnificent in their colours as the *Assumption*.

Titian's fame brought him for the first time into contact with foreign princes. Alfonso d'Este, Duke of Ferrara, employed him to decorate the Alabaster Chamber which already contained Bellini's *Feast of the Gods* and perhaps a picture by Dosso. Titian's canvasses must have brought a youthful freshness into the imposing room, firstly with the host of tender, rosy little bodies in the *Worship of Venus* and then with the ringing musicality of the *Bacchanal* (1518–20, both now in the Prado; Nos. 72–73). The third picture, the London *Bacchus and Ariadne* (No. 92) followed during 1523. The Dionysian themes taken from the *Images of Philostratus* and the *Metamorphosis* of Ovid are interpreted with a rich chromatic harmony which blends pure gold, emerald green, ultramarine and coral. It was not until the next century that a similar warmth was to infuse the figures and landscapes painted in Poussin's limpid classicism and in the sweet *cantabile* style of Claude Lorraine.

In the same period, with inexhaustible creative energy, Titian produced two more important religious works: the *Ancona Altarpiece* of 1520 (No. 83) and the *Averoldi*

Altarpiece of 1522, in Brescia (Nos. 86A–86E). The latter work in particular shows Titian's obvious modification of Mannerist modes indirectly learned through Pordenone. These are apparent not only in the figures but also in the dramatic, almost dreamlike landscapes of both works, which contain views of Venice and Brescia.

It was a period in which Titian painted many masterpieces of portraiture. In one group, dating mainly from the early 1520s, he still uses the half-figure, emerging from a dark, indistinct background, and the characteristic 'signals' which draw the spectator's attention: the Louvre *Man with the Glove* (No. 76) and the Munich (No. 79), Berlin (No. 81), Vienna (No. 77) and Hampton Court (No. 78) *Portraits*. In a second group, which may have been painted shortly afterwards, he adds external elements to the principal figures: a window in the Dublin *Castiglione* (No. 96), a falcon in the Omaha *Portrait* (No. 99), the soft-coated Maltese terrier against the blue costume in the Prado *Federico Gonzaga* (No. 100), the Moorish servant boy as foil to the striking beauty of the Kreuzlingen *Laura Dianti* (No. 101). The series ends with the mysterious Pitti Palace portrait of a man, supposed to be *Vincenzo Mosti*, painted in about 1526 (No. 107) with its greys and blacks which Velázquez was to admire.

In the second half of the 1520s came two more masterpieces: the Pesaro votive picture for the altar of the Frari church (No. 108) and the *St Peter the Martyr* altarpiece at San Zanipolo (No. 117). It is significant that these were the two most important convent churches in Venice, where the foremost notables of the Republic were buried, and the *sacra conversazione* in the Frari, with the *Madonna and Child and SS Peter and Anthony*, is at the same time an impressive portrait of the Pesaro family, one of the richest and best known in Venice. The figures, young and old, are drawn with startling realism despite the pomp of their costume and the family colours recalling glorious feats of the past. Reds blaze on the papal flag, a reminder of the victory over the Turks at Santa Maura (1502); crimson sings out in the velvet tunics of the senators; changing reflections glimmer in the silk robes of the Holy Family and, over all, the brilliant light of the sun triumphs, giving the startling impression of a window in the dark wall of the church.

Only a short time elapsed between completion of the Pesaro altarpiece (27 May 1526) and the commissioning of the San Zanipolo altarpiece, which was handed over on 27 April 1530. Unfortunately, only copies remain of the latter work, the original having been lost in a fire in 1867. From the seventeenth-century reproduction attributed to Loth which today hangs above the altar, and numerous prints and the preparatory drawings now in Lille and the Louvre, we can recognize Titian's extraordinarily dynamic invention. The scene of the saint's assassination is placed on the edge of a wood. The arms of a fleeing monk are raised against the sky, on which the trembling branches of the trees are ominously imprinted, so that the forces of nature participate in the horrific event. In this, Titian had created a completely original dramatic motif, which was quickly appreciated by his contemporaries, whose interest in it is proved by the innumerable copies made of the work.

Meanwhile Titian had met Cecilia, the young woman from his home town who had come as housekeeper to the Vecellio household. She was to give him his first two children, Pomponio and Orazio, and he married her in 1525. Unfortunately she died five years later, giving birth to Lavinia. This close relationship was therefore a brief interlude and Titian was soon alone again. Nevertheless a trace of this domestic background can perhaps be discerned in certain paintings of that period: the *Madonna of the Rabbit* in the Louvre (No. 116) may have used Cecilia as the gentle model in this intimate family scene; and again the unusual Louvre *Allegory* (No. 136), although painted later, may be an outline portrait of the artist's family, showing Cecilia and Titian himself, depicted as a soldier taking leave of his bride. The memory of youthful love which Titian would have associated with Cecilia may have played a part in the extraordinary *Magdalene* which he painted, possibly in 1531, for Federico Gonzaga and which is now in the Pitti Palace (No. 135): in this nude figure, glimpsed through waves of golden hair, light itself conveys the sensual effect.

Through Federico Gonzaga, Titian had meanwhile come into contact with the Emperor Charles V, who was destined to play a decisive role in his future. The monarch had stayed in Bologna for a long period in 1529–30 for the coronation and Titian met him for the first time on that occasion. Unfortunately only copies remain of a portrait which he began then (No. 122). A second meeting took place, also in Bologna, in 1532–3. The outcome of this occasion was probably the portrait of the Emperor with a dog, now in the Prado (No. 147). The story goes that Charles paid Titian only one ducat for the first portrait; in return for the second, he elevated him to the rank of Palatine Count, a title of which the artist was always immensely proud. The Prado portrait, it must be said, is not outstanding, and it was apparently copied from a prototype by the court painter, the Austrian Seisenegger; but it did open the way to a relationship with the imperial court which was to develop steadily as the years went by.

Another very important commission came from the rulers of Urbino. Titian painted an imposing portrait of the duke, which is today in the Uffizi (No. 177), with that of his wife Eleonora Gonzaga (No. 178). He also painted for the duke the mysterious lady called 'La Bella' – in the canvas now in the Pitti Palace (No. 164). She appears again, scantily dressed in a fur in the Vienna portrait (No. 168) and in not much more in the Leningrad portrait (No. 167). It is doubtful whether this is the same woman as the one reclining on a bed in the *Venus of Urbino*, today in the Uffizi (No. 172), although it was commissioned by Prince Guidobaldo, son of Francesco Maria and future duke of Urbino. In this reminder of Giorgione's nude *Venus* (which seems surprising considering its date, 1538), Titian has produced his most seductive image, in a dense vibration of amber lights: a figure from a dream but tangible at the same time, an Olympic ideal but also living proof of a never-ending yearning for vitality. It is significant that both Ingres and Monet copied it, three centuries later. Fairly soon after the Urbino Venus Titian painted another masterpiece: the *Pardo Venus* of the Louvre (No. 221) which also returns to Giorgionesque motives, but gives powerful emphasis to sensual forms,

expressing them in the fullness of coalescing, vibrant colours.

Two large works mark the transitional period between the fourth and fifth decades: the *Presentation of the Virgin* (No. 176), painted for the Scuola della Carità in Venice (Accademia; completed 1538) and the Vienna *Ecce Homo* (No. 222), painted in 1543 for the Flemish merchant Jan van Haanen. In both, the scenes are presented against architectural perspectives inspired by theatrical scenery.

The pattern of the figures is developed according to a system of balance new to Titian. One authority (Pallucchini, 1969) suggests that he was becoming increasingly aware of the style of Romano–Tuscan school, represented at this time in Venice by the two Salviati and by Vasari himself (who had arrived in the city to direct Aretino's *Talanta*). Pordenone, who was the first exponent of Mannerism in the city, was now dead, and Titian may have felt freer to make use of imported Michelangelesque foreshortenings. This is evident in the ceiling for Santo Spirito (1542–4), today transferred to the sacristy of the Church of the Salute (Nos. 226A–226C), and also in the muscular *Christ Crowned with Thorns* done for Santa Maria delle Grazie in Milan, and today in the Louvre (No. 230). But despite his willingness to learn from new trends, Titian was not made for the fine drawing of the Tuscans and Romans, and the value of the works painted at this time still lies in the vitality of their colours and in the way he uses the play of light to achieve a new kind of dynamism.

A journey to Rome, so long postponed, now became almost obligatory. Titian accepted an invitation from Cardinal Alessandro Farnese, from whom he also hoped to receive favours for his son Pomponio, who was a priest, and he set off in 1545. There is little information about the eight months spent in Rome but it is possible that he was not always happy there. A glimpse of the lack of generosity of the Farnese family can be had from the letters in which the painter, at great length, and in vain, asks for promises to be kept (for example, the benefice of the abbey of San Pietro in Colle near Conegliano for Pomponio). Of the numerous paintings made for Alessandro and for his uncle, the elderly Pope Paul III, none, it seems, was paid for, for

Titian's insistent, indignant requests never received a reply. Despite these troubles, Titian's poetic genius was not affected, as can be seen from the portraits of Pope Paul III seated (No. 248) and of the Pope with his two nephews (No. 250), both now at Capodimonte. They are masterpieces, both in their psychological insight and in the way in which the forms are abstracted from simple naturalistic data. They still today give the impression of immense power. Their emotional atmosphere is perfectly expressed through the almost painfully broken colours, which are put on in layers of glazes, and which seem to mirror a soul in torment.

Titian could not have loved Rome: this is confirmed by the total lack of any reference to the city in his letters or in anecdotes related in the sources. When Michelangelo visited Titian's studio and saw the extraordinary *Danaë* (No. 255), painted for the perfidious Ottavio Farnese, he remarked – according to Vasari – that the Venetians could not draw, although they were good at handling colours. We do not know Titian's reply, but in a sense it can be found in the works he carried out as soon as he returned to Venice, among them the Vendramin portrait now in London (No. 264). The brushstrokes sweep over the canvasses like molten glass poured from the Murano furnaces, to be blown into the impalpable forms of images eternally variable in the transparent atmosphere.

Meanwhile letters were arriving from Charles V then residing at Augsburg: after his victory at the battle of Mühlberg against the Protestants, he was waiting for his Court Painter to make the images which would immortalize his triumph. The *Portrait of Charles V on Horseback*, today in the Prado (No. 283), establishes, in iconography and in colour, a model for this kind of subject conveying a sense both of classical 'presence' and dramatic action; the portrait is both imposing and intuitive, combining a feeling of great power with one of human vulnerability. A measure of Titian's influence on later artists is found in the echo of this work discernible in the equestrian portraits of Velázquez and in those of Rubens and van Dyck, painted a century later. This painting was followed by a more intimate portrait of the emperor seated, wearing a black robe (No. 284) which is today in Munich. It seems to explore deeply in a soul tormented by political doubts and spiritual anguish. Soon, the abdication of Charles V and the succession of Philip II was to herald the last phase of Titian's life.

Note on Catalogue

All measurements are in centimetres
s.d. = signed and dated
Those works that are lost are not reproduced,
* except as indicated*
W.I = Wethey, Titian, The Religious Paintings
W.II = Wethey, Titian, The Portraits
W.III = Wethey, Titian, The Mythological and
* Historical Paintings*
and the following number gives the relevant page
V. followed by a number refers to the catalogue by
* F. Valcanover in Cagli, C., Tiziano*
P. followed by a number refers to a page in
* Pallucchini, R., Tiziano, vol. I*

The present volumes on Titian represent a new catalogue of all the master's work based on consideration of all the documentary sources and critical works, and also on my long study of the painter.

Wethey, Valcanover and Pallucchini are the most complete bibliographical sources for the paintings yet published, but I do not necessarily hold the same critical views.

Research on documentary sources and critical works was by Dr Filippo Pedrocco.

The Birth of Adonis (No. 8; detail)
The lively, naturalistic landscapes found in Titian's earliest works were the product of lessons learned from Giorgione as well as from his obvious interest in themes used in Dürer's engravings.

Catalogue of the Paintings

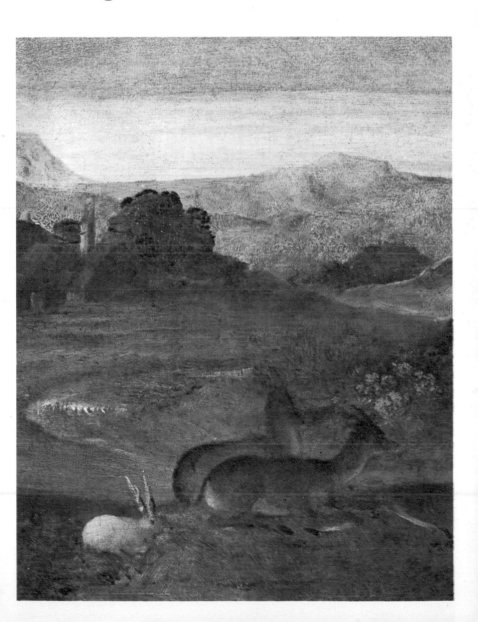

1 *Nativity* (P. 232)
Oil on panel/19 × 16.2/before
1508
Raleigh, North Carolina
Museum of Art

**FRESCOES FROM THE
FONDACO DEI
TEDESCHI IN VENICE**
(Nos. 2A–2L)

2A *Judith* (W.III, 155)
Detached fresco, transferred
onto canvas/345 × 212/*c.* 1508
Venice, Galleria Franchetti,
Ca' d'Oro
**2B *Battle between Monsters
and Giants*** (W.III, 155)
Detached fresco, transferred
onto canvas/158 × 320.5/
c. 1508
Venice, Galleria Franchetti,
Ca' d'Oro
2C *Triton and a Putto* (W.III,
155)
Detached fresco, transferred
onto canvas/157 × 328/*c.* 1508
Venice, Galleria Franchetti,
Ca' d'Oro
2D *Putto fighting a Monster*
(W.III, 155)
Detached fresco, transferred
onto canvas/157.5 × 376/
c. 1508
Venice, Galleria Franchetti,
Ca' d'Oro
2E *A Levantine* (W.III, 155)
Detached fresco, transferred
onto canvas/241 × 159/*c.* 1508
Venice, Galleria Franchetti,
Ca' d'Oro
2F *An Oriental*
Detached fresco, transferred
onto canvas/241 × 159/*c.* 1508
Venice, Doge's Palace
2G *Coat of Arms*
Detached fresco, transferred
onto canvas/327 × 153/*c.* 1508
Venice, Galleria Franchetti,
Ca' d'Oro
**2H '*Compagno della Calza*':
*A member of the
Confraternity of the Calza*** (V.
9)
Lost (Zanetti, 1760: *c.* 1508)
2I *Female figures* (V. 9)
Lost (Zanetti, 1760: *c.* 1508)
2L *Nude Woman Standing* (V.
9)
Lost (Piccini, 17th century:
c. 1508)

**3 *Portrait of a Gentleman of
the Barbarigo Family*** (V. 1)
Lost (Vasari, 1568: *c.* 1508)

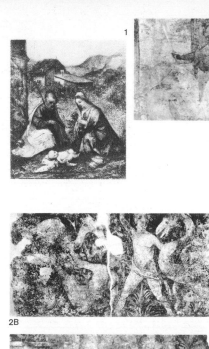

1

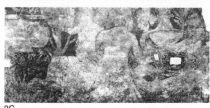

2A

2B

2E

2F

2C

2D

2G

2Ia

2Ha

2La

4a

5

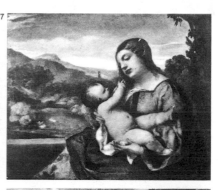

7

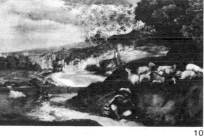

10

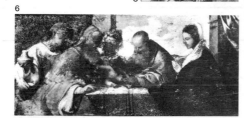

6

8

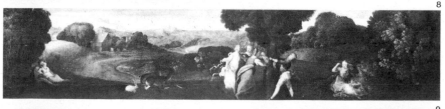

9

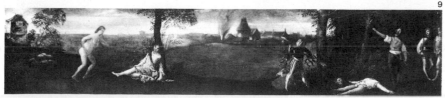

11

4 Frescoes in the Palazzo Grimani in Venice (V. 10)
Lost (Vasari, 1568: *c.* 1509).
An engraving by Zanetti showing *Diligence* (Photo 4a)

5 Lucretia (P. 232)
Oil on canvas/122.5 × 58/ 1508–11
Formerly in Munich, Fleischmann Gallery

6 The Circumcision (W.I, 171)
Oil on panel/36.7 × 79.3/ 1508–11
New Haven, Yale University Art Gallery

7 Madonna and Child (W.I, 174)
Oil on panel/38 × 47/1508–11
Bergamo, Accademia Carrara (Lochis Collection)

8 The Birth of Adonis (W.III, 206)
Oil on panel/35 × 162/ 1508–11
Pendant to No. 9
Padua, Museo Civico

9 The Forest of Polydorus (W.III, 206)
Oil on panel/35 × 162/ 1508–11
Pendant to No. 8
Padua, Museo Civico

10 Pastoral (W.III, 213)
Oil on panel/42 × 66/1508–11
Milan, Canessa Collection

11 Endymion (W.III, 213)
Oil on panel/28 × 127/ 1508–11
Merion, Pennsylvania, Barnes Foundation

Pastoral Concert (No. 15)
Inspired by a familiar Giorgionesque theme, this Pastoral Concert transforms the inherent melancholy of its model into a sensuous composition of landscape and figures, expressed with a new density of colour.

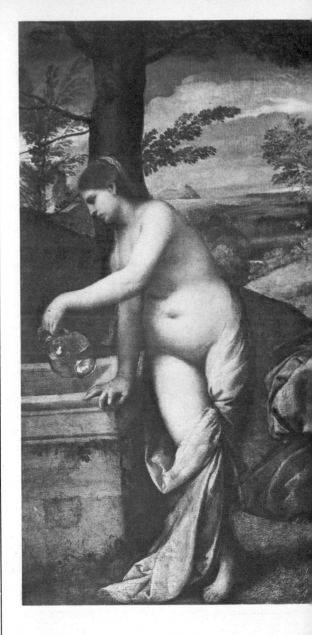

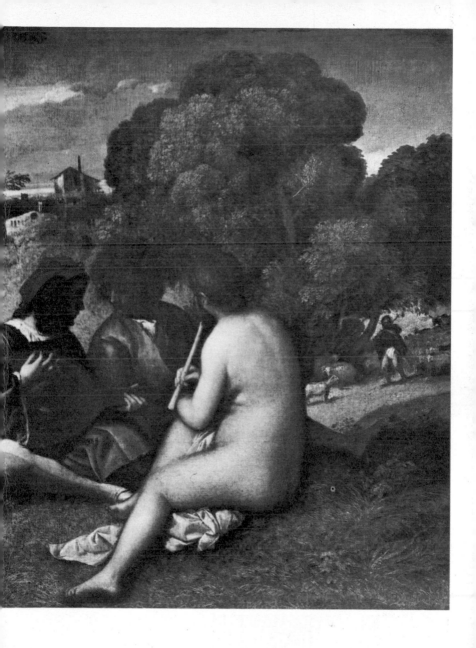

12 Moses in the Burning Bush (?) (W.III, 215)
Oil on canvas/59.9 × 144.8/
1508–11
London, Courtauld Institute
13 Orpheus and Eurydice
(W.III, 167)
Oil on panel/39 × 53/1508–11
Bergamo, Accademia Carrara
(Lochis Collection)
14 The Flight into Egypt (W.I,
171)
Oil on canvas/206 × 336/
1508–11
Leningrad, The Hermitage
15 Pastoral Concert (W.III,
167)
Oil on canvas/110 × 138/
1508–11
Paris, Louvre

St Peter, Pope Alexander VI and Bishop Jacopo Pesaro (No. 16; detail)
The painting relates to the victory over the Turks at Santa Maura (1502) by Bishop Pesaro and the Borgia pope (who died in 1503). It was however painted at a later date. The superb iridescent colours are a foretaste of those in the Assumption *in the church of the Frari (No. 71).*

The Concert (No. 20)
(pp. 18–19)
Although the idea is Giorgionesque, this triple portrait nevertheless bears the unmistakable mark of Titian in the underlining of psychological and physical characteristics. Restoration has disclosed highlights on the keyboard player's dark habit.

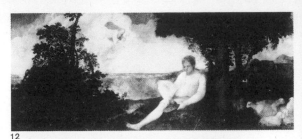

12

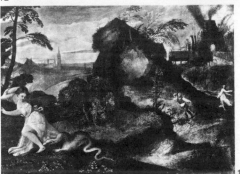

13

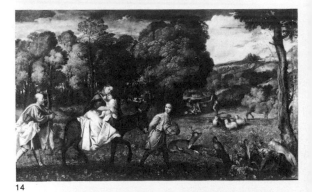

14

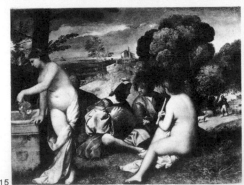

15

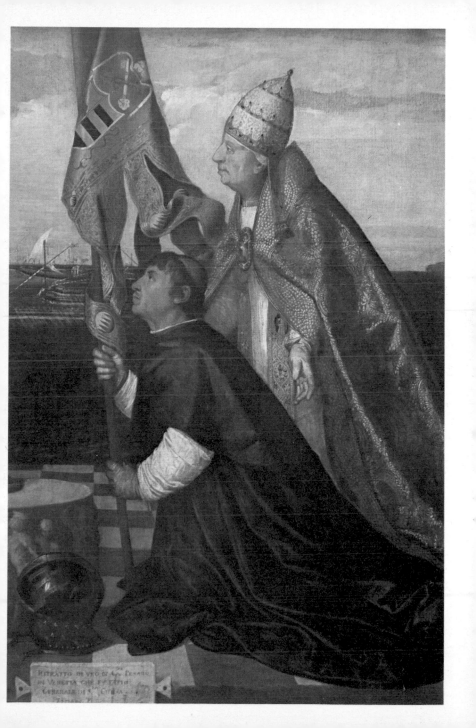

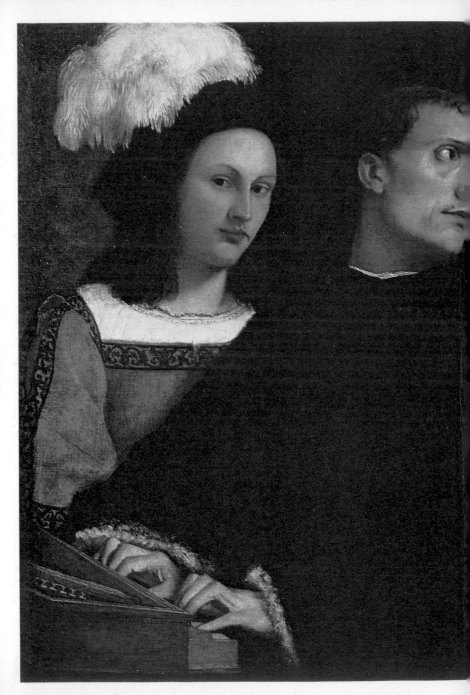

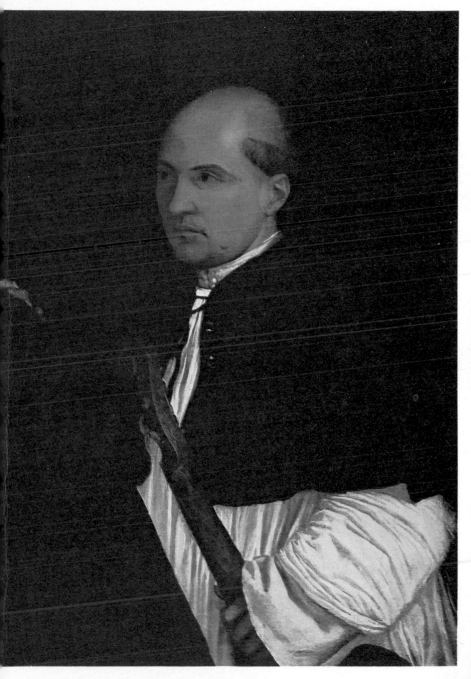

16 St Peter, Pope Alexander VI and Bishop Jacopo Pesaro: the Votive Painting of Bishop Pesaro (W.I, 152)
Oil on canvas/145 × 183/ 1508–11
Antwerp, Musée Royal des Beaux-Arts

17 Madonna and Child, SS Anthony of Padua and Roch (W.I, 174)
Oil on canvas/92 × 133/ 1508–11
Madrid, Prado

18 The Gypsy Madonna (W.I, 98)
Oil on panel/65.8 × 83.8/ 1508–11
Vienna, Kunsthistorisches Museum

19 Madonna and Child (W.I, 98)
Oil on panel/46 × 56/1508–11
New York, Metropolitan Museum

20 The Concert (W.II, 91)
Oil on canvas/86.5 × 123.5/ 1508–11
Florence, Pitti Palace

The Miracle of the Speaking Babe (No. 28A)
A new dynamism underlies the composition and the expressive means used by Titian in the three scenes from the life of St Anthony painted in 1511. The figures are dramatic, there are lively portraits and the landscape is an integral part of the emotional atmosphere created in each of the scenes.

16

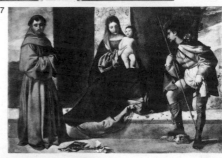

17

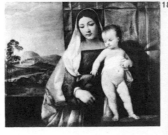

18

19

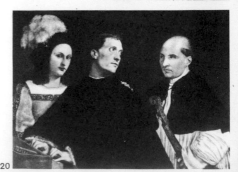

20

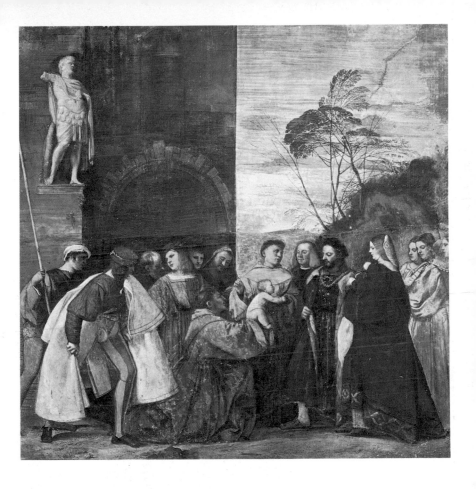

21

21 Portrait of a Knight of Malta (W.II, 113)
Oil on canvas/80 × 64/
1508–11
Florence, Uffizi
22 Portrait of a Man (V. 69)
Oil on canvas/58 × 45/
1508–11
Bordeaux, Musée des Beaux-Arts
23 Supposed Portrait of Ariosto (W.II, 77)
Oil on canvas/59.5 × 45.5/
1508–11
Indianapolis, J. Herron Art Institute
24 Portrait of a Man (W.II, 186)
Oil on canvas/50.2 × 45.1/
1508–11
New York, Metropolitan Museum
25 Portrait of a Man (W.II, 189)
Oil on canvas/69 × 52/
1508–11
Pasadena, Norton Simon Museum
26 Portrait of a Gentleman dressed in Black
Oil on canvas/88.8 × 70.1/
1508–11
Florence, Pitti Palace
27 Portrait of a Woman (V. 29)
Oil on canvas/31.7 × 24.1/
1508–11
Pasadena, Norton Simon Museum

Portrait of a Woman: the Serving Woman (No. 45; detail)
Titian's early portraits tend towards simplicity in the use of colour. This portrait, in which the subject is contrasted with her own profile in marble not reproduced in this detail, centres on the red-brown dress, which emerges from greenish shadows.

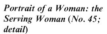

21

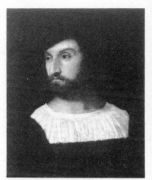

22

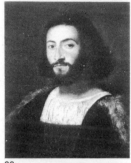

23

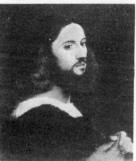

24

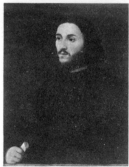

25

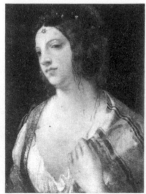

27

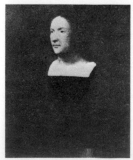

26

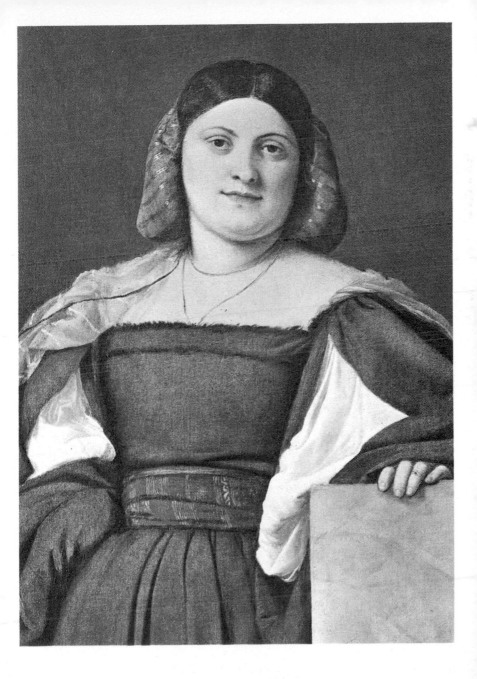

FRESCOES IN THE SCUOLA DI SANT'ANTONIO (Nos. 28A–28C) Padua, Scuola del Santo

28A The Miracle of the Speaking Babe (W.I, 128)
Fresco/340 × 355/1511
28B The Miracle of the Irascible Son (W.I, 128)
Fresco/340 × 207/1511
28C The Miracle of the Jealous Husband (W.I, 128)
Fresco/340 × 185/1511

29 Portrait of Pietro Bembo (V. 45)
Lost (Vasari, 1568: 1513). Probably the painting from which P. de Jode made the engraving 'Pietro Aretino' (Photo 29a)
30 Pastoral (V. 63)
Lost (Vasari, 1568: c. 1515)

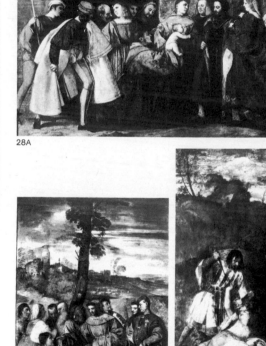

28A

28B

28C

29a

Portrait of a Man: the so-called 'Ariosto' (No. 46)
Contemporary sources name Titian as a master of the portrait, both for the powerful realism and the depth of introspective analysis. The massive blue and silver sleeve makes this picture unforgettable. The subject has been identified, probably incorrectly, as the poet Ariosto.

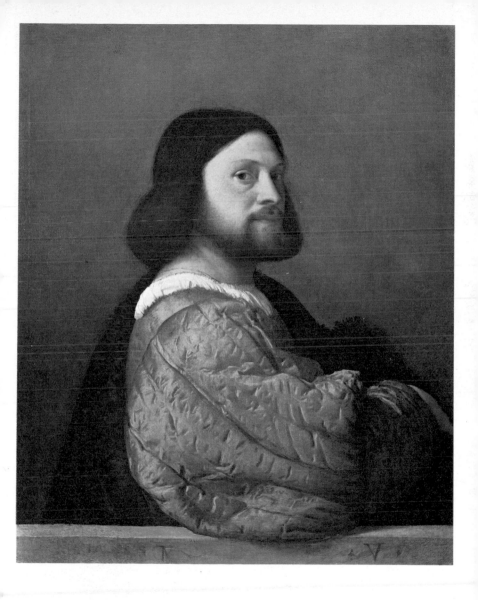

31 Cornelia and Pompey
(V. 513 and 589)
Lost (Ridolfi, 1648: c. 1515).
Copy in Florence, Casa
Buonarroti (Photo 31a)

**32 The Adulteress before
Christ** (W.I, 169)
Oil on canvas/137 × 180/
1511–17
Glasgow, Museum and Art
Galleries

33 Bust of a young Soldier
(P. 237)
Oil on canvas/54.5 × 43.5/
1511–17
Glasgow, Museum and Art
Galleries
Fragment of No. 32

**34 St Mark enthroned, with
SS Cosmas and Damian, Roch
and Sebastian (Santo Spirito
Altarpiece)** (W.I, 143)
Oil on panel/230 × 149/
1511–17
Venice, Church of Santa
Maria della Salute

31a

33

32

**Portrait of a Young Girl:
Violante (No. 53)**
*This is one of the finest of the
series of beautiful female
portraits painted by Titian in
between about 1511 and 1517.
It is too sensuous and its
colours too forceful for it to
bear any relation to the
Giorgionesque models which
influenced Titian's earliest
portraits and which he had by
now surpassed.*

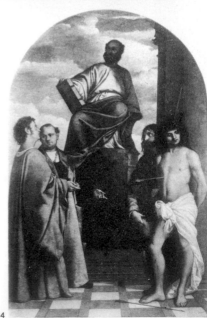
34

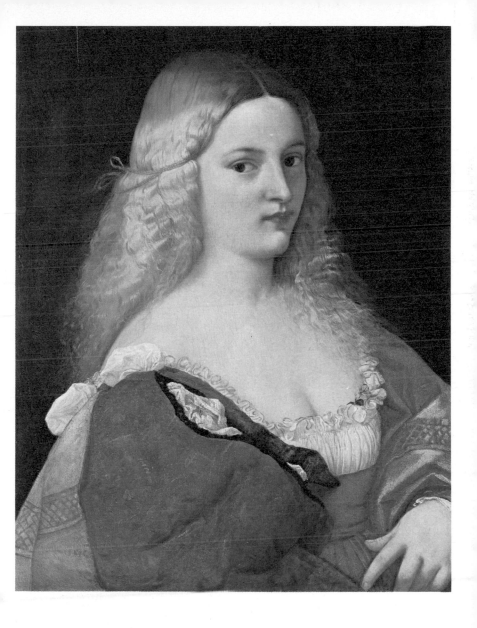

35 'Noli me tangere' (W.I, 119)
Oil on canvas/109 × 91/ 1511–17
London, National Gallery
36 The Baptism of Christ (W.I, 76)
Oil on canvas/115 × 89/ 1511–17
Rome, Capitoline Museum
37 The Three Ages of Man (W.III, 182)
Oil on canvas/106 × 182/ 1511–17
Edinburgh, National Gallery of Scotland

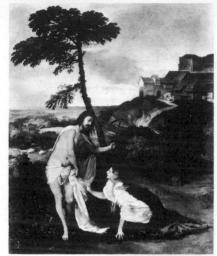

35

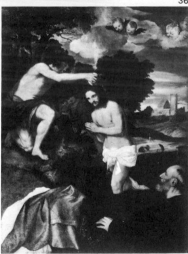

36

37

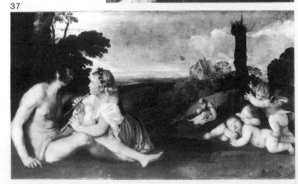

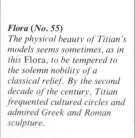

Flora (*No. 55*)
The physical beauty of Titian's models seems sometimes, as in this Flora, *to be tempered to the solemn nobility of a classical relief. By the second decade of the century, Titian frequented cultured circles and admired Greek and Roman sculpture.*

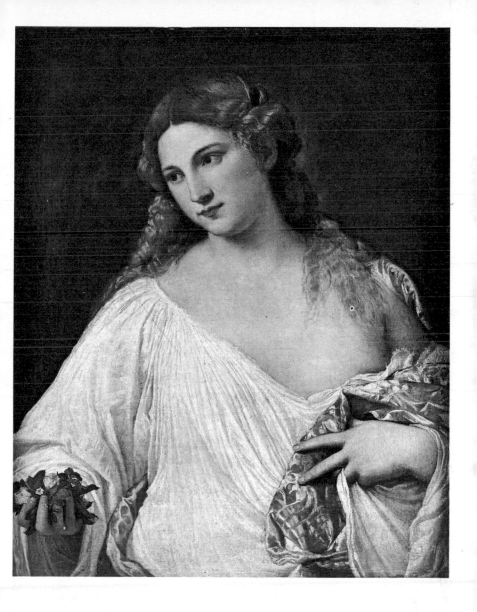

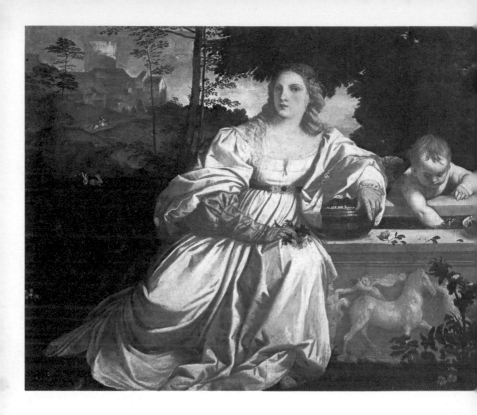

**Sacred and Profane Love
(No. 56)**
*This painting, which may
represent Celestial Venus
(nude, carrying a lamp) and
Terrestrial Venus (clothed and
bejewelled), was probably
executed for Chancellor
Nicolò Aurelio. It is a supreme
example of the artist's ability
to harmonize elements of
classical culture with his own
ideal of beauty.*

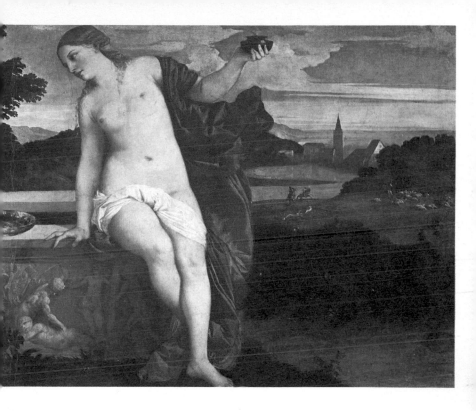

38 Rest on the Flight into Egypt (W.I, 125)
Oil on panel/46.5 × 64/
1511–17
London, Marquis of Bath
Collection

39 Rest on the Flight into Egypt (V. 13)
Oil on canvas/91 × 160/
1511–17
Formerly in Florence,
Contini Bonacossi Collection

40 The Holy Family and a Shepherd (W.I, 94)
Oil on canvas/99 × 137/
1511–17
London, National Gallery

41 Madonna and Child, St John the Baptist, and the Donor (W.I, 94)
Oil on canvas/90 × 120/
1511–17
Edinburgh, National Gallery
of Scotland

38

39

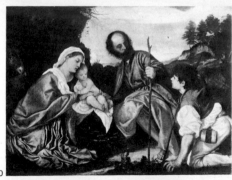

40

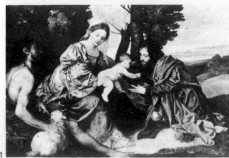

41

The Assumption (No. 71)
Placed in 1518 above the high altar of the Church of Santa Maria dei Frari, this work marked Titian's first public triumph: contemporaries compared him to Michelangelo and Raphael. Recent restoration of the huge panel has disclosed an unexpected brilliance of design and colour.

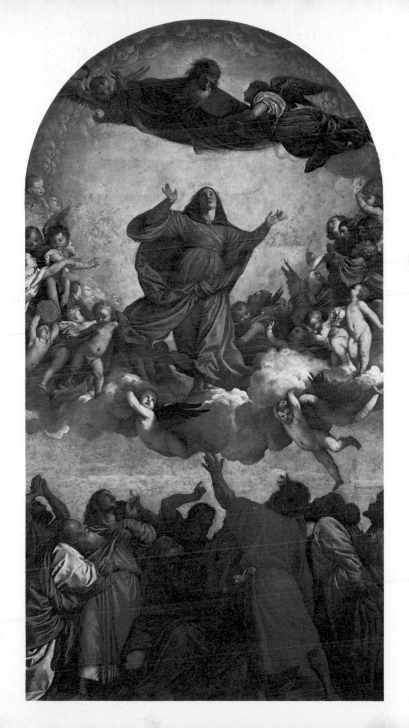

42 Madonna and Child, SS Jerome and Dorothy (W.I, 175)
Oil on canvas/58.5 × 86.5/
1511–17
Glasgow Museum and Art Galleries
43 Madonna and Child, St John the Baptist, and the Donor (W.I, 176)
Oil on canvas/75 × 92/
1511–17
Munich, Alte Pinakothek
44 Madonna and Child, SS Catherine and Dominic, and the Donor (W.I, 106)
Oil on canvas/130 × 185/
1511–17
La Gaida (Reggio Emilia), Luigi Magnani Collection
45 Portrait of a Woman: the Serving Woman (W.II, 139)
Oil on canvas/117 × 97/s./
1511–17
London, National Gallery
46 Portrait of a Man: the so-called 'Ariosto' (W.II, 103)
Oil on canvas/81.2 × 66.3/s./
1511–17
London, National Gallery

The Worship of Venus
(No. 72; detail)
Together with the Bacchanal *which is also now in the Prado (No. 73), the* Bacchus and Ariadne *now in London (No. 92) and with another picture by Bellini and perhaps one by Dosso, this work was executed for Alfonso d'Este's Alabaster Chamber in the Ducal Castle at Ferrara. Painted when Titian was 30 years old, it is a masterpiece of 'chromatic classicism'.*

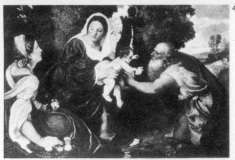
42

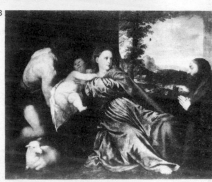
43

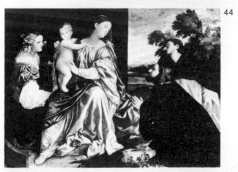
44

45

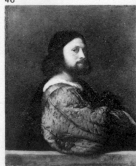
46

47 Portrait of a bearded Gentleman (W.II, 153)
Oil on canvas/82 × 65/ 1511–17
Alnwick Castle, Duke of Northumberland Collection

48 Portrait of a Man (W.II, 105)
Oil on canvas/80.5 × 66.5/ 1511–17
Copenhagen, Statens Museum for Kunst

49 Salome (W.I, 157)
Oil on canvas/90 × 72/ 1511–17
Rome, Doria Gallery
There is a version of the painting in Pasadena

50 Young Woman at her Toilet (W.III, 162)
Oil on canvas/96 × 76/ 1511–17
Paris, Louvre
There are versions of this painting in Barcelona, Prague and Washington

51 Vanity (W.III, 184)
Oil on canvas/98 × 81/ 1511–17
Munich, Alte Pinakothek

52 Young Woman in a black Dress (W.II, 155)
Oil on canvas/59.5 × 44.5/ 1511–17
Vienna, Kunsthistorisches Museum

53 Portrait of a young Girl: Violante (W.II, 188)
Oil on panel/64.5 × 51/ 1511–17
Vienna, Kunsthistorisches Museum

Bacchanal (No. 73)
Part of a series, together with the preceding work, the Bacchanal *canvas praises the joys of life, enlivened by the pleasures of Bacchus. An air of musical festivity pervades the dancing figures who are clothed in the fresh and fluid colours which Titian's rich palette produced increasingly during the 1520s.*

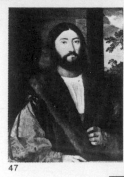
47

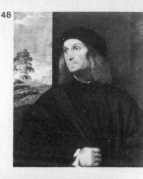
48

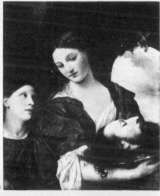
49

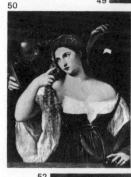
50

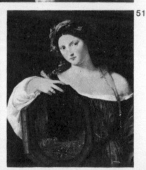
51

52

53

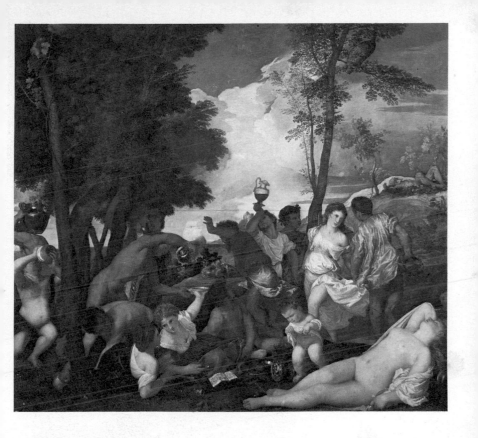

54 Tarquin and Lucretia
(W.III, 219)
Oil on panel/84 × 68/1511–17
Vienna, Kunsthistorisches
Museum
55 Flora (W.III, 154)
Oil on canvas/79 × 63/
1511–17
Florence, Uffizi
56 Sacred and Profane Love
(W.III, 175)
Oil on canvas/118 × 279/
1511–17
Rome, Borghese Gallery
*57 Portrait of a young Man in
a Fur* (W.II, 149)
Oil on canvas/82.3 × 71.1/
1511–17
New York, Frick Collection
58 Portrait of a young Man
(W.II, 166)
Oil on canvas/90 × 73/
1511–17
Ajaccio, Musée Fesch
59 Portrait of a young Man
(W.II, 149)
Oil on canvas/100 × 84/
1511–17
Garrowby Hall, Earl of
Halifax Collection
*60 Portrait of a young Man in
a Fur* (W.II, 165)
Oil on panel/70 × 54/1511–17
Munich, Alte Pinakothek

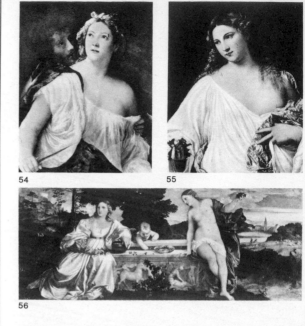

54 55

56

57 58

59 60

The Man with the Glove
(No. 76)
*The psychological insight and
spiritual quality of Titian's
portraits often depend on
some visual feature which
becomes a kind of 'signal'.
Here, the subject has one bare
hand and the other gloved,
giving rise to the work's
traditional title.*

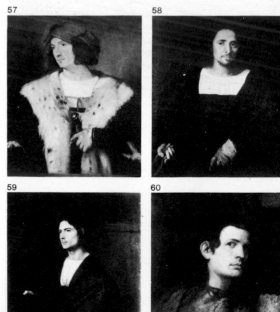

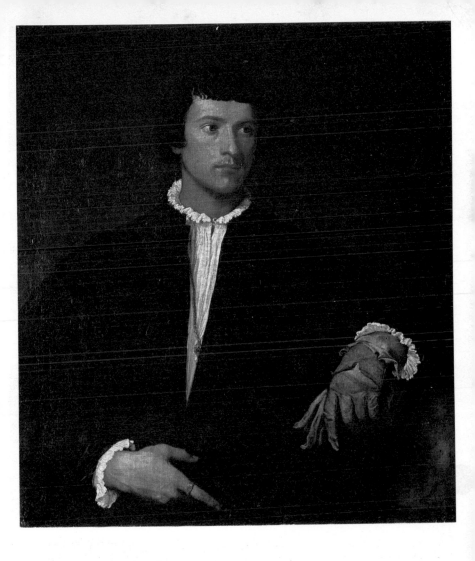

61 The Bravo (W.III, 130)
Oil on canvas/75 × 67/
1511–17
Vienna, Kunsthistorisches
Museum
**62 Young Man with a Feather
in his Hat** (W.II, 104)
Oil on canvas/81 × 63.5/
1511–17
Petworth House (National
Trust)
**63 Portrait of a Musician
(Battista Ceciliano?)** (W.II,
188)
Oil on canvas/99 × 81.8/
1511–17
Rome, Spada Gallery
64 The Tribute Money (W.I,
163)
Oil on panel/75 × 56/1511–17
Dresden, Gemäldegalerie
65 The Bath (V. 79)
Lost (letter from Titian to
Alfonso d'Este, 1517)
**66 The Risen Christ, with
Prophets** (V. 80)
Lost: documented 1517
67 St George (W.I, 132)
Oil on panel/124.6 × 65.7/
c. 1517
Fragment of a painting of St
Michael between SS
Theodore and George
Venice, Cini Collection
**68 The Madonna of the
Cherries** (W.I, 99)
Oil on canvas, transferred
onto panel/81 × 99.5/1517–18
Vienna, Kunsthistorisches
Museum

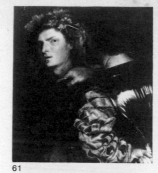

61

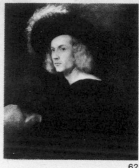

62

63

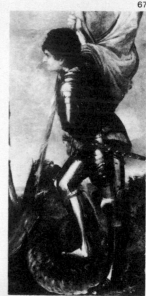

67

64

**Madonna and Child in Glory
with SS Francis and Alvise,
and the Donor (No. 83)**
*Titian's religious painting of
the 1520s reached, in the
realistic treatment of figures,
both saints and donors, its
true, expressive maturity. This
may be seen in this altarpiece
which shows the donor Alvise
Gozzi, together with the
patron saints and the Virgin.*

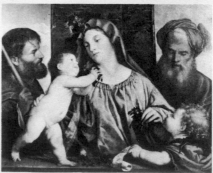

68

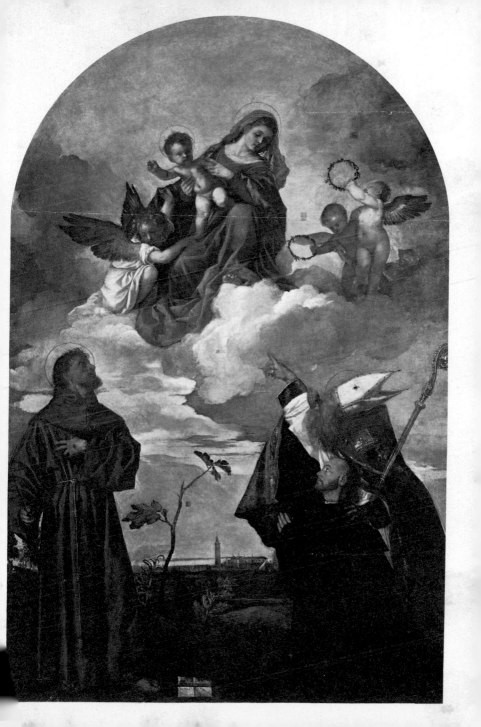

69 Madonna and Child, and SS Ulfus and Bridget (W.I, 109)
Oil on panel/86 × 130/ 1517–18
Madrid, Prado
70 Sacra Conversazione (W.I, 110)
Oil on panel/139 × 191/ 1517–18
Dresden, Gemäldegalerie
71 The Assumption (W.I, 74)
Oil on panel/690 × 360/1518
Venice, Church of Santa Maria Gloriosa dei Frari

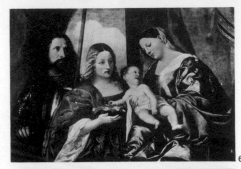

69

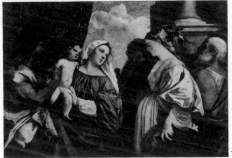

70

Madonna and Child in Glory with SS Francis and Alvise and the Donor (No. 83; detail)
The attractive landscape vista, with a view of St Mark's – the belltower, the basilica and the Doge's Palace – introduced a motive that was to be used again and again. The twilight accentuates the visionary, dramatic quality of the landscape.

71

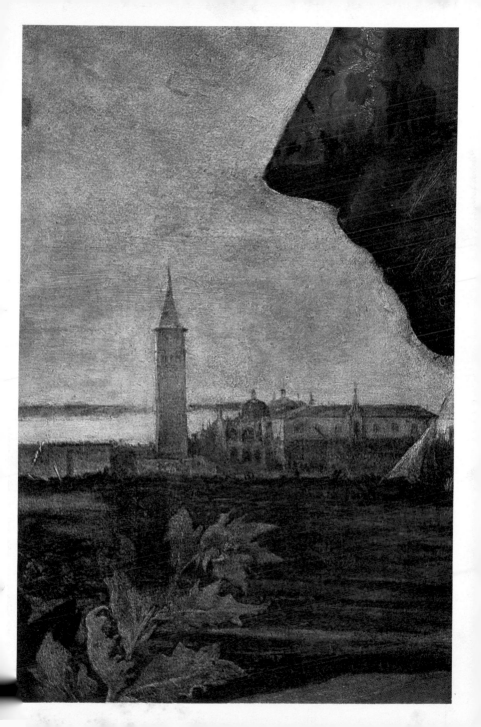

72 The Worship of Venus
(W.III, 146)
Oil on canvas/172 × 175/
1518–19
Madrid, Prado
73 Bacchanal (W.III, 151)
Oil on canvas/175 × 193/
1518–20
Madrid, Prado
74 Venus Anadyomene (W.III,
187)
Oil on canvas/73.6 × 58.4/
1518–20
Edinburgh, National Gallery
of Scotland
75 Lucretia (W.III, 166)
Oil on canvas/95.2 × 62.2/
1518–20
Hampton Court, Royal
Collection
76 The Man with the Glove
(W.II, 118)
Oil on canvas/100 × 89/
1518–20
Paris, Louvre
77 Portrait of a Man (W.II,
121)
Oil on canvas/88 × 75/
1518–20
Vienna, Kunsthistorisches
Museum
*78 Portrait of a Man of
Letters* (W.II, 138)
Oil on canvas/84 × 72/
1518–20
Hampton Court, Royal
Collection
79 Portrait of a Man (W.II,
105)
Oil on canvas, applied to
panel/89 × 74/1518–20
Munich, Alte Pinakothek
80 Portrait of a Man (W.II,
105)
Oil on canvas/118 × 96/
1518–20
Paris, Louvre
81 Portrait of a Man (W.II,
106)
Oil on canvas/94 × 72/
1518–20
Berlin, Staatliche Museen
*82 Portrait of a Gentleman of
the Farnese Household* (W.II,
99)
Oil on canvas/105 × 84/
1518–20
Pommersfelden, Schönborn
Collection

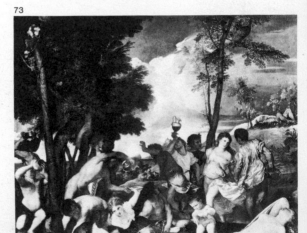

72

73

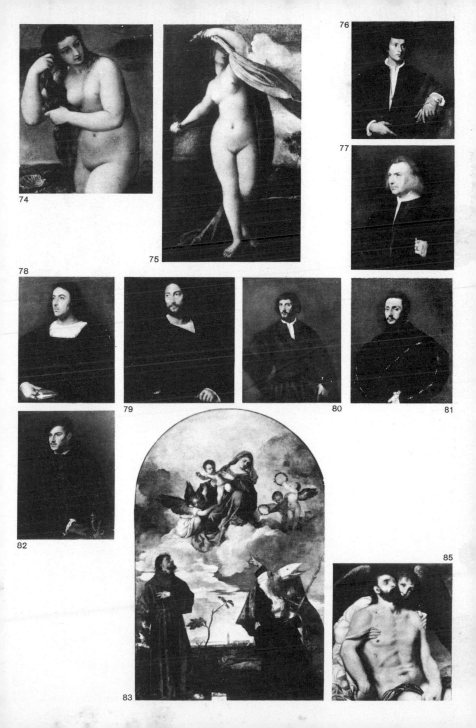

74

75

76

77

78

79

80

81

82

83

85

*83 Madonna and Child in
Glory, SS Francis and Alvise,
and the Donor (W.I, 109)*
Oil on panel/312 × 215/1520
Ancona, Museo Civico
84 The Judgment of Solomon
(V. 104)
Lost (Vasari, 1568: 1521)
*85 The Dead Christ supported
by an Angel (P. 262)*
Oil on canvas/76.3 × 63.2/
c. 1521
Collaboration between
Giorgione and Titian (only
the figure of Christ)
New York, private collection

*Polyptych of the Resurrection:
The Averoldi Polyptych
(Nos. 86A–86E)*
*Commissioned by the Papal
Legate to Venice, Altobello
Averoldi, who appears in
sharply defined profile on the
left, the altarpiece places the
figures in a dramatically
crepuscular landscape, lit by
flashes of iridescent light.*

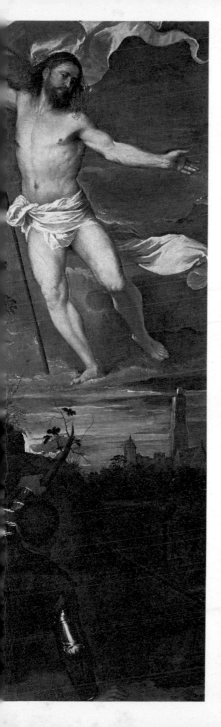

AVEROLDI POLYPTYCH:
(POLYPTYCH OF THE
RESURRECTION) (W.I.
126)
(Nos. 86A–86E)
Brescia, Church of SS
Nazzaro and Celso

86A The Resurrection
Oil on panel/278 × 122/1522
86B SS Nazzaro and Celso,
and the Donor
Oil on panel/170 × 65/1522
86C St Sebastian
Oil on panel/170 × 65/1522
86D The Angel of the
Annunciation
Oil on panel/79 × 65/1522
86E The Virgin Annunciate
Oil on panel/79 × 65/1522

87 Submission of Frederick
Barbarossa to Pope Alexander
III in Venice (V. 106)
Lost (Vasari, 1568:
completed in 1522)
88 Portrait of the Doge
Antonio Grimani (V. 109)
Lost: documented 1523

86A

86D

86E

Portrait of Federico Gonzaga,
Duke of Mantua (No. 100)
Titian's patron in the 1520s,
Federico Gonzaga, introduced
him to the court of Charles V,
whose favourite painter Titian
later became. The soft white
coat of the dog is a foil to the
luminous gold-embroidered
blue of the prince's superbly
painted doublet.

86B

86C

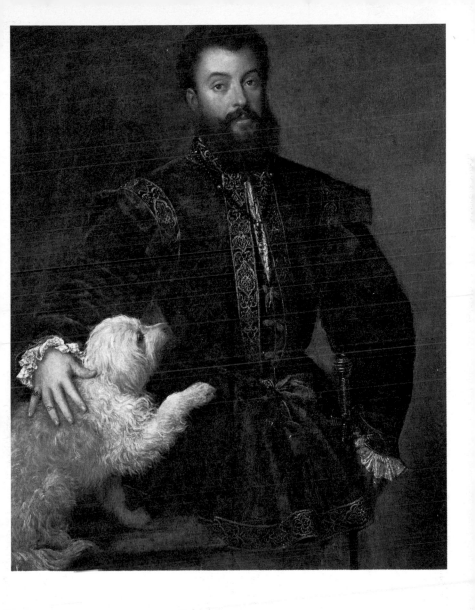

89 St Christopher (W.I, 131)
Fresco/300 × 179/1523
Venice, Doge's Palace
90 Frescoes in the Chapel of the Doge's Palace (V. 110)
Lost: documented 1523
91 Portrait of Federico Gonzaga, Duke of Mantua (V. 112)
Lost: documented 1523
92 Bacchus and Ariadne (W.III, 148)
Oil on canvas/175 × 190/1523
London, National Gallery
93 Portrait of Alfonso I, Duke of Ferrara (V. 115 and 116)
Lost (Vasari, 1568: 1523). There is a probable copy in New York, Metropolitan Museum (Photo 93a)
94 Portrait of Laura Dianti (V. 117)
Lost (Vasari, 1568: 1523) or could be 101
95 Portrait of the Doge Andrea Gritti (V. 120)
Lost: documented 1523
96 Portrait of Baldassar Castiglione (W.II, 85)
Oil on canvas/124 × 97/1523(?)
Dublin, National Gallery of Ireland
97 Portrait of Cristoforo Marcello (V. 121)
Lost (Michiel: *ante* 1525)
98 An unidentifiable subject (V. 514)
Lost (Michiel: *ante* 1525)
99 Man with a Falcon (W.II, 96)
Oil on canvas/109 × 94/s./1523–6
Omaha, Joslyn Art Museum

Portrait of Vincenzo Mosti (?) (*No. 107*)
The subjects in Titian's portraits are often presented in an enigmatic or questioning attitude, as is this supposed representation of Vincenzo Mosti, a high dignitary at the court of the d'Este family at Ferrara. His pale face stands out against the black-edged lace collar with a melancholy, and at the same time commanding, expression.

89

93a

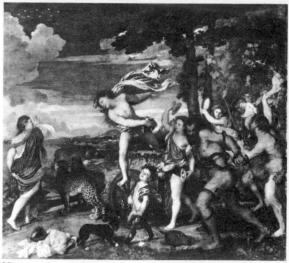

92

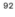

96

99

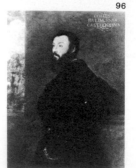

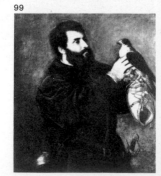

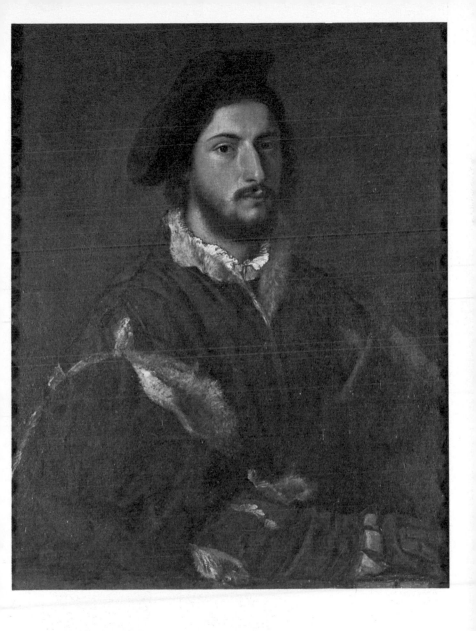

100 Portrait of Federico
Gonzaga, Duke of Mantua
(W.II, 107)
Oil on canvas/125 × 99/s./
1523–6
Madrid, Prado
101 Portrait of Laura Dianti
(W.II, 92)
Oil on canvas/119 × 93/s./
1523–6
Kreuzlingen, Kisters
Collection
102 Madonna and Child, with
SS Stephen, Jerome and
Maurice (W.I, 113)
Oil on canvas/108 × 132/
1523–6
With the assistance of others
Paris, Louvre
103 Madonna and Child, with
SS Stephen, Jerome and
Maurice (W.I, 144)
Oil on panel/92.5 × 138/
1523–6
A version of No. 102
Vienna, Kunsthistorisches
Museum

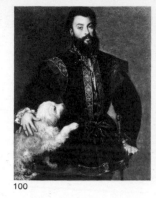
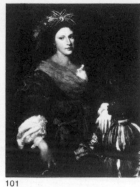

100

101

102

103

The Pesaro Altarpiece
(No. 108)
With this votive picture of the
Pesaro family, executed
between 1519 and 1526, Titian
showed how a great religious
work could also be a superb
family portrait. Recent
restoration has proved that
this sacra conversazione *was*
originally placed within an
architectural structure, and
then moved out of doors,
against the perspective of two
massive columns.

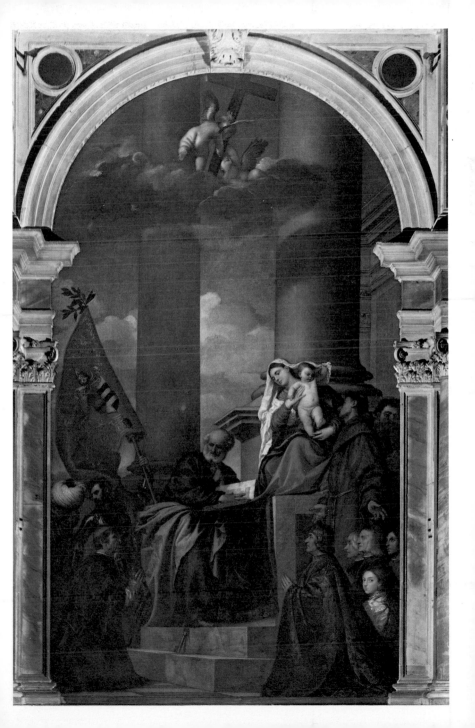

104 Christ at Emmaus (W.I, 161)
Oil on canvas/169 × 244: mutilated on the right side/s./ 1523–6
Paris, Louvre
105 Christ at Emmaus (W.I, 160)
Oil on panel/169 × 211/s./ 1523–6
A version of No. 104
Yarborough, Brocklesby Park
106 The Entombment (W.I, 89)
Oil on canvas/148 × 205/ 1523–6
Paris, Louvre

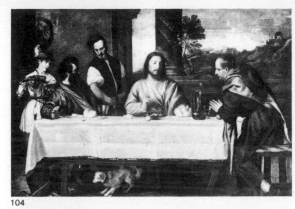

104

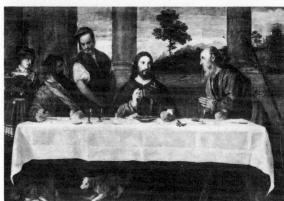

105

106

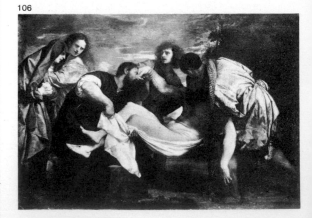

The Pesaro Altarpiece (No. 108; detail)
The warrior-bishop Jacopo Pesaro, who defeated the Turks at Santa Maura, is seen kneeling on the left under the colours of his family and those of the Borgia pope. The gleaming red of the flag is reflected in the armour and accentuates the forceful profile of Pesaro, who commissioned the altarpiece.

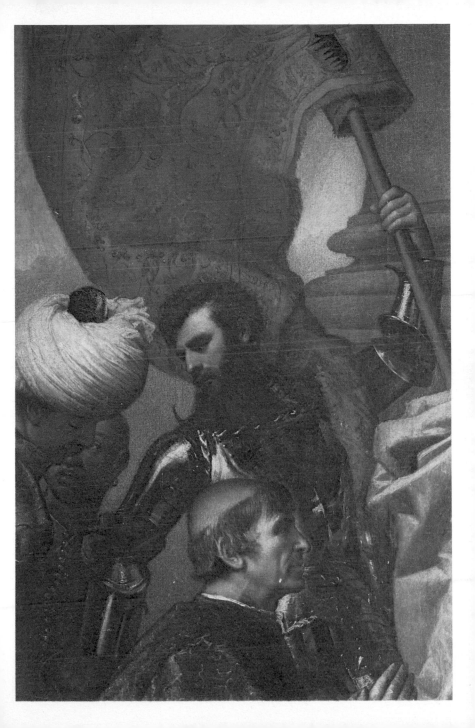

107 Portrait of Vincenzo Mosti (?) (W.II, 119)
Oil on canvas/85 × 66/1526 (?)
Florence, Pitti Palace
108 The Pesaro Altarpiece (W.I, 101)
Oil on canvas/478 × 268/1526
Venice, Church of Santa Maria Gloriosa dei Frari
109 Portrait of Girolamo Adorno (V. 129)
Lost (letter from Titian to Federico Gonzaga, 1527)
110 Portrait of Pietro Aretino (V. 130)
Lost: documented 1527
111 Two half-length figures fighting (V. 515)
Lost (Michiel: *ante* 1528)
112 The Annunciation (W.I, 69)
Oil on panel/210 × 176/ 1526–31
With the assistance of others
Treviso, Duomo, Malchiostro Chapel

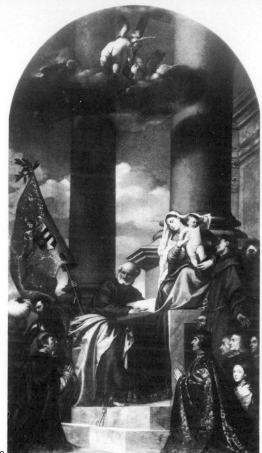

108

The Pesaro Altarpiece (No. 108; detail)
The other members of the Pesaro family are seen on the right of the painting: Benedetto (not in this detail), Vittorio, Antonio, Fantino and the young Giovanni. The latter figure is particularly effective, the gilded-white silk fabric setting off the childish features.

107

112

56

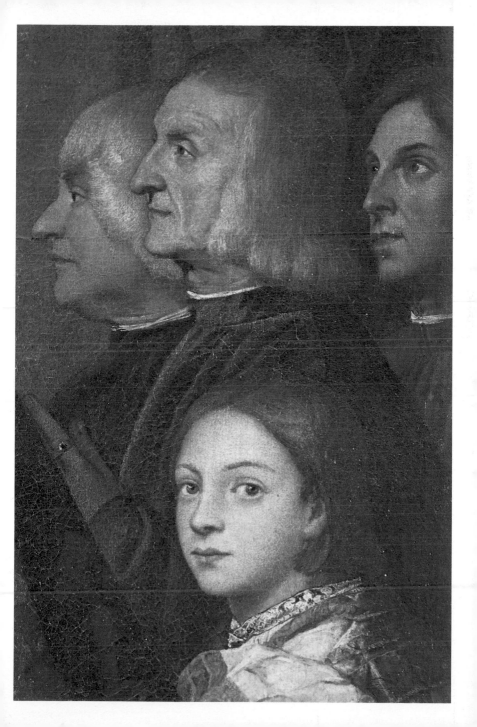

113 St Francis receiving the Stigmata (W.I, 131)
Oil on canvas/281 × 195/
1526–31
In poor condition
Trapani, Museo Pepoli

114 Madonna and Child, with the young St John and St Anthony Abbot (W.I, 103)
Oil on canvas/67 × 95/
1526–31
Florence, Uffizi

115 Madonna and Child, with the young St John and St Catherine (W.I, 104)
Oil on canvas/101 × 142/
1526–31
London, National Gallery

116 The Madonna of the Rabbit (W.I, 105)
Oil on canvas/71 × 85/
1526–31
Paris, Louvre

117 The Death of St Peter the Martyr (V. 137)
Lost: documented 1530.
Drawings in Lille, Musée
Wicar (Photo 117a)
Engraved by M. Rota (Photo
117b)

118 Portrait of Federico Gonzaga II (V. 138)
Lost: documented 1530

119 Nude female figures
(V. 139)
Lost (letter from Titian to
Federico Gonzaga, 1530)

120 Madonna and Child, with the young St John and St Catherine (V. 140)
Lost: documented 1530

121 Altarpiece (V. 141)
Lost (letter from Titian to
Isabella d'Este, 1530)

122 Portrait of Charles V
(V. 144)
Lost (Vasari, 1568: 1530)

123 Portrait of Cornelia, lady-in-waiting to Elisabetta, Countess of Pepoli (V. 145)
Lost: documented 1530

124 St Sebastian (V. 146)
Lost: documented 1530

125 St John the Baptist
(V. 147)
Lost: documented 1531

126 The Adulteress (V. 148)
Lost (Vasari, 1568: 1531)

127 St Jerome (V. 149)
Lost (letter from Titian to
Federico Gonzaga, 1531)

113

114

115

116

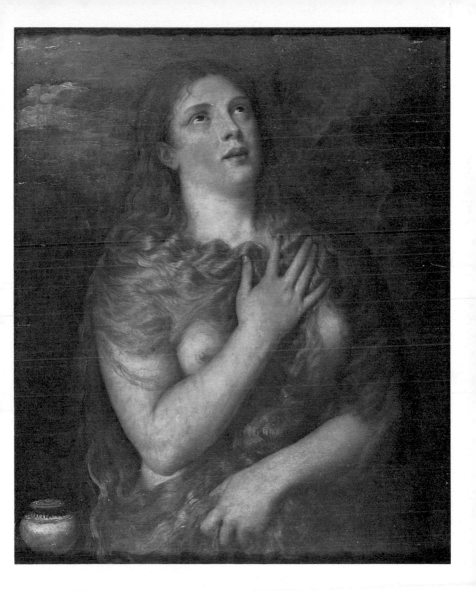

St Mary Magdalene in Penitence (*No. 135*)
Titian's choice of models is often of great significance. His Magdalene *is particularly original; the saint is here represented by a beautiful woman clothed only in the golden tresses of her own hair.*

128 Votive painting of the Doge Andrea Gritti (V. 151)
Lost: documented 1531.
There exists an anonymous engraving (Photo 128a)
129 St Mary Magdalene (V. 152)
Lost: documented 1531
130 St Jerome (W.I, 133)
Oil on canvas/80 × 102/1531 (?)
Paris, Louvre
131 Madonna and Child, with the young St John and a Female Saint (V. 517)
Lost (Michiel: *ante* 1532)
132 The Supper of Christ (V. 518)
Lost (Michiel: *ante* 1532)
133 The Assumption of the Virgin (W.I, 76)
Oil on canvas/392 × 214/1532
Verona, Duomo
134 Portrait of an Animal brought to Venice from Alexandria (V. 153)
Lost: documented 1532
135 St Mary Magdalene in Penitence (W.I, 143)
Oil on panel/84 × 69.2/s./ 1532–3
Florence, Pitti Palace
There is a version of this painting in Rome
136 Allegory (W.III, 127)
Oil on canvas/121 × 107/ 1532–3
Paris, Louvre
137 Portrait of Andrea de' Franceschi (W.II, 100)
Oil on canvas/95 × 70/1532–3
Detroit, Institute of Arts
There are versions of this painting in Washington and Indianapolis
138 Portrait of Giacomo Dolfin
Oil on canvas/105 × 91/ 1532–3
England, private collection
139 Portrait of Prince Giacomo Doria (W.II, 94)
Oil on canvas/115.5 × 98/s./ 1532–3
Luton Hoo, Wernher Collection
140 Portrait of Ippolito de' Medici (V. 159)
Lost (Vasari, 1568: 1532–3)
141 Portrait of Alfonso I, Duke of Ferrara (V. 519)
Lost: documented *ante* 1533

117b

117a

128a

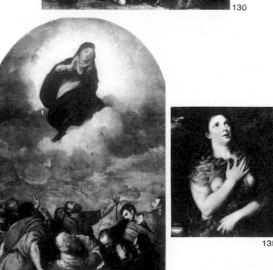

130

133

135

'La Bella' (No. 164)
Another portrait without a name, traditionally given the appropriate title of La Bella. *The lady was probably at the court of Urbino (from where the canvas comes) and she was portrayed on at least three other occasions, in canvases now in Vienna and Leningrad.*

The Venus of Urbino (No. 172) (pp. 62–63)
Commissioned by Guidobaldo della Rovere, later duke of Urbino, in 1538. The subject of this fascinating portrait has never been identified. Titian has taken amber colours from his now sumptuous palette, making them vibrate in the light-filled room, and transforming the original melancholy Giorgionesque model of the Dresden Venus *into an image full of vitality.*

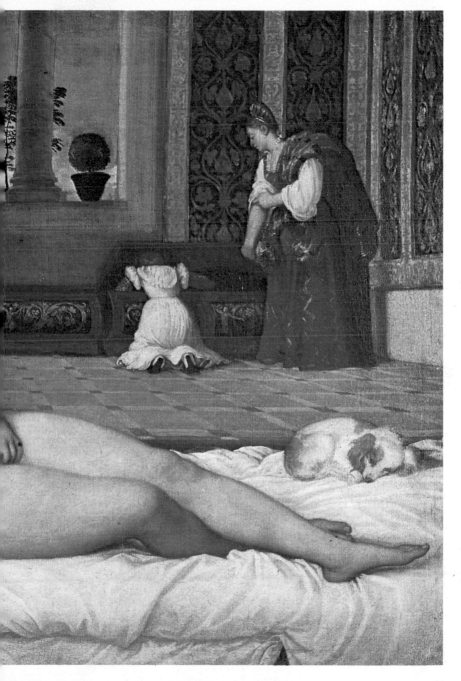

142 Portrait of Ercole, son of Alfonso I, Duke of Ferrara (V. 520)
Lost: documented *ante* 1533
143 Portrait of Charles V (V. 521)
Lost: documented *ante* 1533
144 Judith (V. 522)
Lost: documented *ante* 1533
145 St Michael (V. 523)
Lost: documented *ante* 1533
146 Madonna (V. 524)
Lost: documented *ante* 1533
147 Portrait of Charles V (W.II, 85)
Oil on canvas/192 × 111/1533
Madrid, Prado
148 Portrait of the Constable of Bourbon (V. 165)
Lost: documented *c.* 1533. There is a copy in Bilbao, Marquis of Feria Collection (Photo 148a)
149 Portrait of Antonio da Leva (V. 162)
Lost (Vasari, 1568: 1533)
150 The Nativity (V. 163)
Lost: documented 1533
151 Portrait of Cardinal Ippolito de' Medici (W.II, 119)
Oil on canvas/138 × 106/ 1533–4
Florence, Pitti Palace
152 Portrait of an Old Warrior (W.II, 146)
Oil on canvas/65 × 58/ 1533–4
Milan, Pinacoteca Ambrosiana
153 Adoration of the Shepherds (W.I, 117)
Oil on panel/95 × 115/*c.* 1534
Florence, Pitti Palace
154 Adoration of the Shepherds (P. 267)
Oil on panel/93.7 × 112/ *c.* 1534
Poor state of preservation. A version of No. 153
Oxford, Christ Church
155 Hannibal (W.III, 160)
Oil on canvas/122.5 × 102/ 1534 (?) (not illustrated)
New York, private collection
156 Portrait of the Cardinal of Lorraine (V. 168)
Lost (letter from Titian to Vendramano, 1534)
157 Portrait of a Woman (V. 529)
Lost (letter from Titian to Vendramano, 1534)

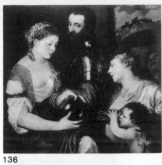
136

137

138

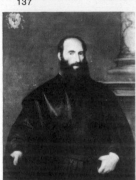
139

147

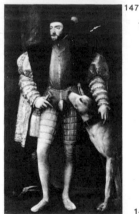
148a

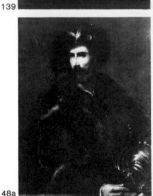
151

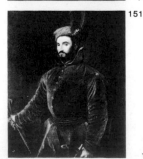
151

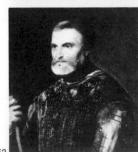
152

153

154

162

164

167

168

169a

170a

171a

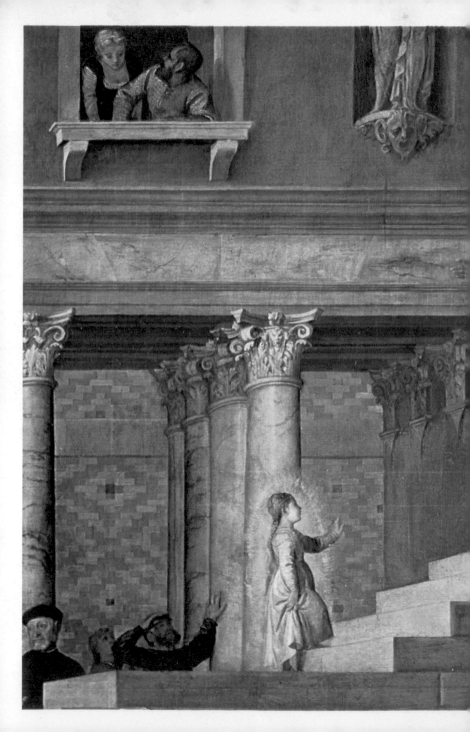

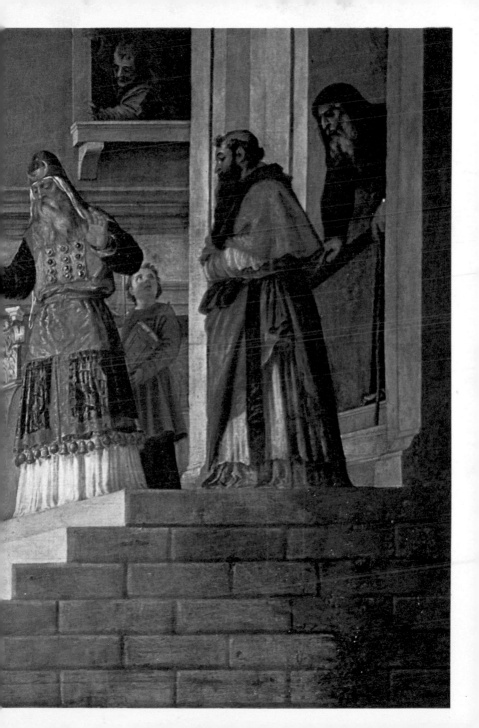

158 The Rape of Proserpina
(V. 525)
Lost: documented 1534
159 Portrait of Charles V
(V. 526)
Lost: documented *c.* 1534
160 Portrait of the Empress of
Spain (V. 527)
Lost: documented *c.* 1534
161 Portrait of Prince Philip
(V. 528)
Lost: documented *c.* 1534
162 Portrait of Isabella d'Este
(W.II, 95)
Oil on canvas/102 × 64/
1534–6
Vienna, Kunsthistorisches
Museum
163 Christ (V. 530)
Lost: documented *c.* 1535
164 'La Bella' (W.II, 81)
Oil on canvas/100 × 75/1536
Florence, Pitti Palace
165 Portrait of Alfonso I,
Duke of Ferrara (V. 175)
Lost: documented 1536
166 Portrait of Charles V
(V. 176)
Lost (letter from Titian to the
Duke of Mantua, 1533;
painting delivered in 1536)
167 Girl with a Feather in her
Hat (W.II, 169)
Oil on canvas/97 × 75/1536–8
Leningrad, The Hermitage
168 Girl in a Fur (W.II, 106)
Oil on canvas/95 × 63/1536–8
Vienna, Kunsthistorisches
Museum
169 The Annunciation (V. 180)
Lost: documented 1537.
Engraved by G. Caraglio
(Photo 169a)
170 Twelve Portraits of
Roman Emperors (V. 182)
Lost: documented 1537–8.
Engraved by E. Sadelez
(Photo 170a)
171 Battle (V. 181)
Lost: documented 1538. The
drawing in Paris, Louvre
(Photo 171a), may have been
an early idea for the painting
172 The Venus of Urbino
(W.III, 203)
Oil on canvas/119 × 165/1538
Florence, Uffizi
173 Madonna and Child (W.I,
99)
Oil on panel/37.5 × 31/s./
c. 1538
Lugano, Thyssen Collection

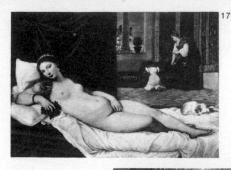
172

173

174

175

176

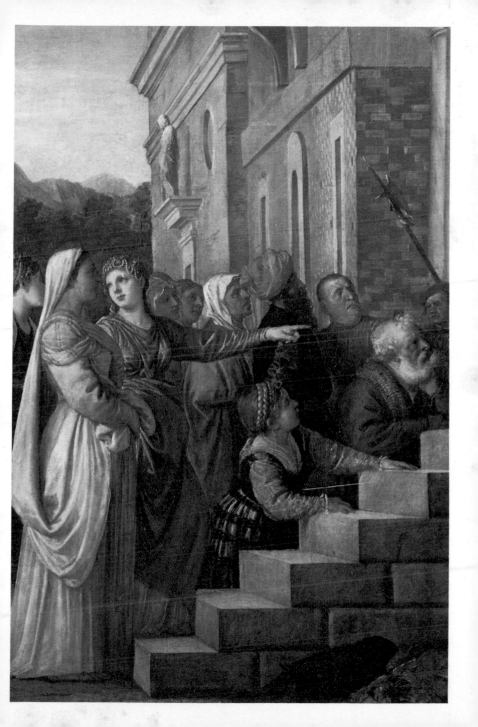

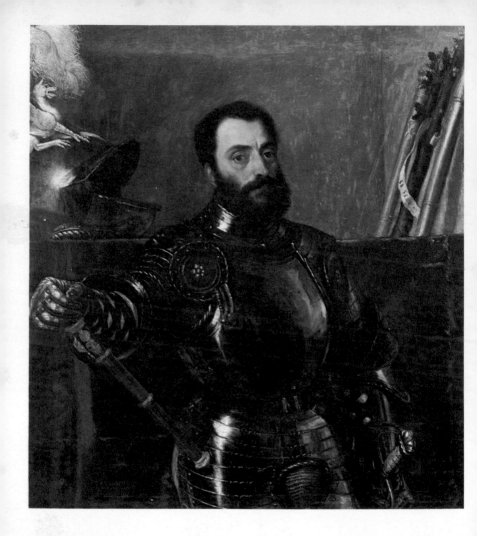

The Presentation of the Virgin in the Temple (*No. 176; detail*) (*pp. 66–67*)
Painted in 1538 for the School of Charity in Venice, it still hangs in the same building, now reconstructed as the Accademia. The allegory of the Virgin climbing the steps of the temple is a reminder of the generosity of the School, which provided the poor girls of the city with dowries.

The Presentation of the Virgin in the Temple (*No. 176; detail*) (*p. 69*)
The School of Charity canvas gave Titian the opportunity of drawing from life a crowd of Venetian notables on their feast day. Sumptuous costumes, solemn gestures, radiant colours, all offer an extraordinary example of the artist's 'chromatic classicism'.

Portrait of Francesco Maria della Rovere, Duke of Urbino (*No. 177*)
Painted in 1538 for the Duke of Urbino, a generous patron of Titian's, this shows the prince in his favourite suit of armour, which was specially sent to Venice as a model. Titian's brush brings out the melancholy, as well as the imperious, in the character of his subject, even in the pomp of this state portrait.

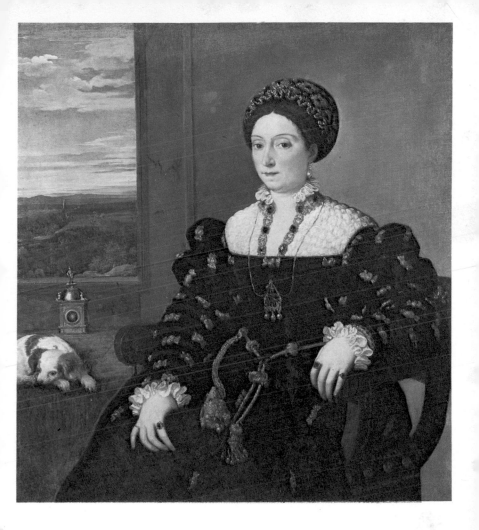

Portrait of Eleonora Gonzaga
(*No. 178*)
*In a pendant to the portrait of
her husband (No. 177),
Eleonora Gonzaga, Duchess of
Urbino, is shown in the
intimacy of her chamber,
beside a window opening on to
the gentle countryside of the
Marches. The dog and clock
represent faithfulness which
lasts beyond time.*

174 Madonna and Child in Glory, with six Saints (W.I, 107)
Oil on panel/338 × 270/s./ 1538
Rome, Vatican Museum
175 Madonna and Child with two Angels (W.I, 100)
Fresco/160 × 350/c. 1538
Venice, Doge's Palace
176 The Presentation of the Virgin in the Temple (W.I, 123)
Oil on canvas/345 × 775/1538
Venice, Accademia
177 Portrait of Francesco Maria della Rovere, Duke of Urbino (W.II, 135)
Oil on canvas/114.3 × 103/s./ 1538
Pendant to No. 178
Florence, Uffizi
178 Portrait of Eleonora Gonzaga, Duchess of Urbino (W.II, 134)
Oil on canvas/114 × 103/1538
Pendant to No. 177
Florence, Uffizi
179 St Jerome (V. 183)
Lost (Vasari, 1568: completed in 1538). Engraved by C. Cort (Photo 179a)
180 Portrait of Guidobaldo, Duke of Camerino (V. 531)
Lost: documented 1538
181 Portrait of Francis I of France (W.II, 102)
Oil on canvas/109 × 89/1538
Paris, Louvre
182 Portrait of Francis I of France (W.II, 101)
Oil on canvas/101 × 83/ 1538–40
Harewood House, Earl of Harewood Collection
183 Portrait of Francis I of France (W.II, 102)
Oil on canvas/80 × 60/ 1538–40
Lausanne, Coppet Collection
184 Portrait of Gabriele Tadino (W.II, 143)
Oil on canvas/118 × 133/ 1538–40
Winterthur, Bühler Collection
185 Portrait of Count Antonio Porcia (W.II, 133)
Oil on canvas/115 × 90/s./ 1538–40
Milan, Brera Gallery

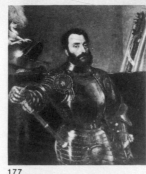

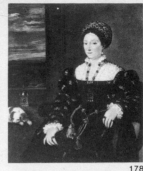

177

178

179a

182

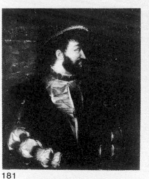

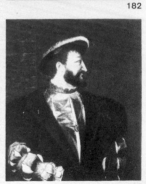

181

183

184

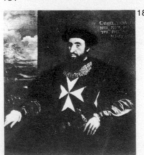

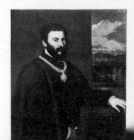

185

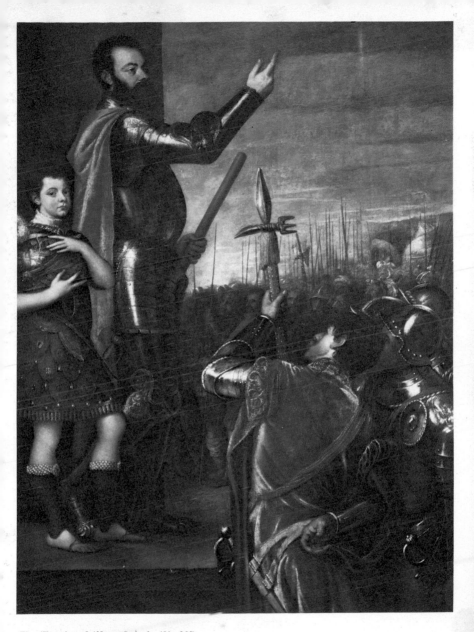

The Allocution of Alfonso d' Avalos (**No. 208**)
Alfonso, Duke of Avalos, Christian condottiere *in
the war against the Turks in 1530, is portrayed by
Titian while addressing his troops. In the uncertain
dawn light the soldier's figure assumes a classical
grandeur perhaps slightly reminiscent of an Allocution
of Trajan on the Arch of Constantine in Rome.*

73

186 George d'Armagnac with Guillaume Philandrier (W.II, 78)
Oil on canvas/104 × 114.3/ 1538–40
Alnwick Castle, Duke of Northumberland Collection
187 Portrait of the Cardinal of Lorraine (V. 191)
Lost: documented 1539
188 Christ (V. 192)
Lost: documented 1539
189 Portrait of Charles V (V. 193)
Lost: documented 1539
190 Portrait of Francis I of France (V. 194)
Lost: documented 1539
191 Portrait of Suliman II (V. 195)
Lost: documented 1539
192 Portrait of Count Agostino Lando (V. 196)
Lost: documented 1539
193 Portrait of Admiral Vincenzo Cappello (W.II, 83)
Oil on canvas/141 × 118/1540 (?)
Washington, National Gallery of Art
There is a version of this painting in New York, Chrysler Collection
194 Portrait of Cardinal Pietro Bembo (W.II, 82)
Oil on canvas/94.3 × 76.5/ 1540 (?)
Washington, National Gallery of Art
195 Portrait of Cardinal Pietro Bembo (V. 200)
Lost (Vasari, 1568: *c.* 1540)
196 The Allocution of Alfonso d'Avalos (model) (V. 203)
Lost: documented 1540
197 Portrait of Alessandro degli Organi (V. 532)
Lost: documented 1540
198 Portrait of Giulia da Ponte di Spilimbergo (V. 204)
Lost (Vasari, 1568: 1540)
199 Portrait of Paolo da Ponte (V. 205)
Lost (Vasari, 1568: 1540)
200 Portrait of Admiral Vincenzo Cappello (V. 206)
Lost: documented 1540
201 Portrait of Don Diego Mendoza (V. 220)
Lost: documented 1540

186

193

194

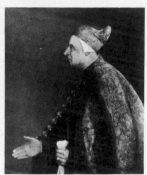
204

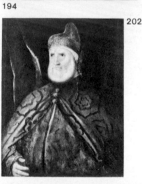
205

202

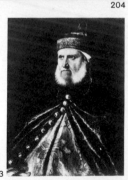
203

206

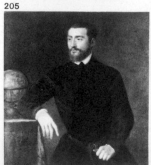

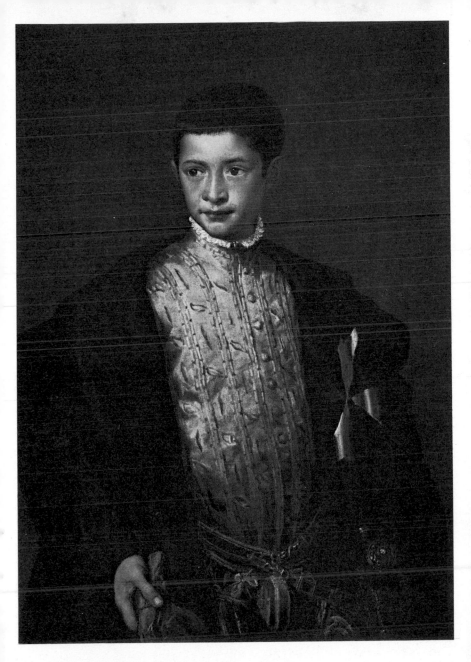

Portrait of Ranuccio Farnese (No. 214)
A member of the family which gave to the Church Pope Paul III, and son of Pier Luigi Farnese, Ranuccio visited Venice in 1542, when he was painted by Titian. A masterpiece of sumptuous pictorial quality and sensitive psychological insight.

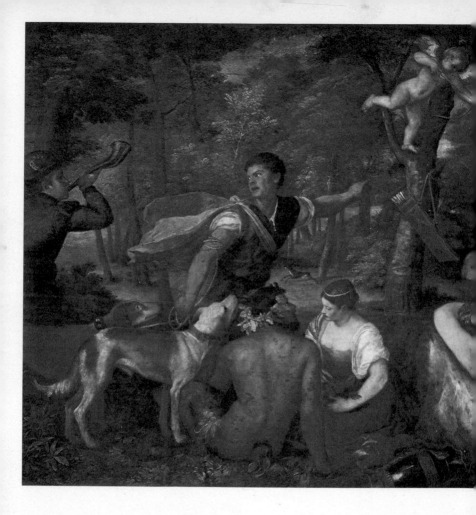

The Pardo Venus (No. 221)
*This large canvas probably
represents the mythological
scene of Jove discovering
Antiope asleep. The nude
figure is reminiscent of models
used in his early works but the
lively, realistic landscape
indicates that the picture was
probably done in the 1540s. Its
title derives from the Pardo
Castle, where the painting
hung in the seventeenth
century.*

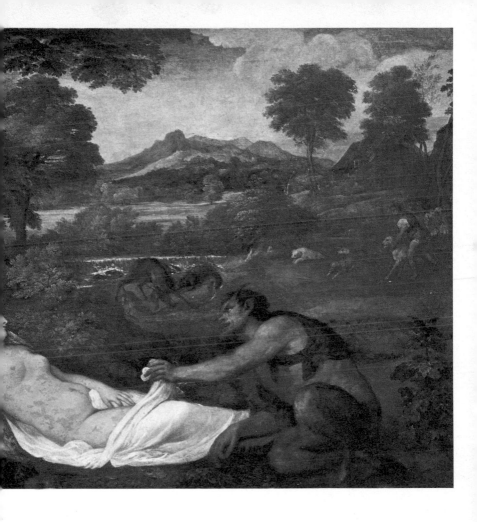

202 Portrait of the Doge Andrea Gritti (W.II, 109)
Oil on canvas/102.2 × 80.7/ 1540–1
New York, Metropolitan Museum

203 Portrait of the Doge Andrea Gritti (V. 210)
Oil on canvas/84.3 × 65.5/ 1540–1
Kenosha, Allen Collection

204 Portrait of the Doge Nicolò Marcello (W.II, 118)
Oil on canvas/103 × 90/ 1540–1
Rome, Vatican Museum

205 Portrait of Gerardo Mercatore (W.II, 174)
Oil on canvas/106 × 91/s./ 1540–1
New Haven, Yale University Art Gallery

206 Portrait of Giulio Romano (W.II, 133)
Oil on canvas/102 × 87/ 1540–1
London, Mark Oliver Collection

207 Portrait of Alfonso d'Avalos (W.II, 78)
Oil on canvas/109 × 85/ 1540–1
Paris, De Ganay Collection

208 The Allocution of Alfonso d'Avalos (W.II, 79)
Oil on canvas/223 × 165/1541
Madrid, Prado

209 Pentecost (V. 219)
Lost (Vasari, 1568: 1541)

210 Portrait of Signor d'Aramont (W.II, 74)
Oil on canvas/74 × 70/s./ 1541–3
Milan, Castello Sforzesco

211 Portrait of a Woman (V. 222)
Lost: documented 1542

212 The Nativity (V. 230)
Lost: documented c. 1542

213 Portrait of Clarice Strozzi (W.II, 142)
Oil on canvas/115 × 98/s.d./ 1542
Berlin, Staatliche Museen

214 Portrait of Ranuccio Farnese (W.II, 98)
Oil on canvas/89.7 × 73.6/s./ c. 1542
Washington, National Gallery of Art

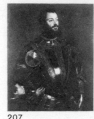

207

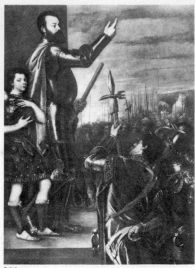

208

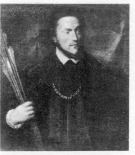

210

213

215

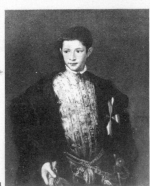

214

215 Portrait of Pope Paul III
(W.II, 122)
Oil on canvas/114 × 89/1543
(?)
Naples, Galleria Nazionale di
Capodimonte
**216 Votive painting of the
Doge Pietro Lando** (V. 233)
Lost: documented 1542–3
**217 Madonna and Child, with
SS Luke and Catherine** (W.I,
107)
Oil on canvas/124.5 × 167.6/
1542–3
Kreuzlingen, Kisters
Collection
A workshop variation exists
at Hampton Court
**218 Madonna and Child, with
St Mary Magdalene** (P. 294)
Oil on canvas/104 × 92.5/
1542–3
By Titian and his workshop
New York, private collection
**219 Madonna and Child, with
St Mary Magdalene** (W.I,
111)
Oil on canvas/98 × 82/1542–3
A version of No. 218
Leningrad, The Hermitage
220 The Annunciation (W.I,
70)
Oil on canvas/166 × 266/
1542–3
Venice, School of San Rocco
221 The Pardo Venus (W.III,
161)
Oil on canvas/196 × 385/
1542–3
Paris, Louvre

**Christ Crowned with Thorns
(No. 230) (p. 79)**
*Titian painted the picture for
the Church of Santa Maria
delle Grazie in Milan, shortly
before he went to Rome. The
finely articulated composition
enhances the plastic dynamism
of the figures, showing the
influence of Mannerism in
which during this phase Titian
displayed some interest.*

217

218
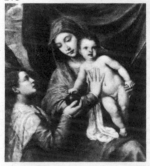

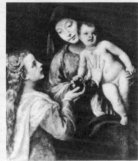
219

220

221

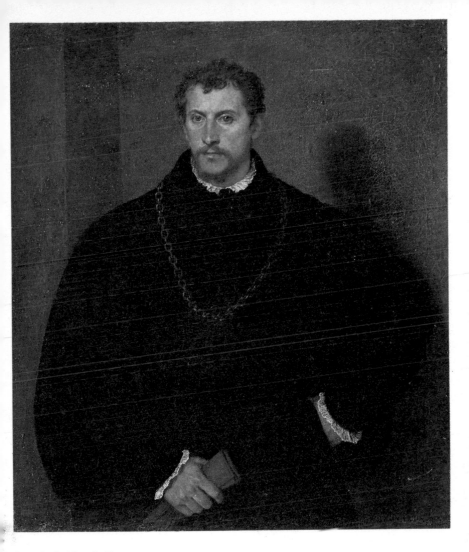

**Portrait of a Man; the Young
Englishman** (*No. 235*)
*Despite Ippolito Riminaldi's
attempt to identify the subject,
this fascinating portrait of a
man with blue-green eyes
remains popularly known as
the mysterious 'Englishman'.
The face and hands emerge
from the shadows, they seem
to indicate a determined and
grave character.*

222 Ecce Homo (W.I, 79)
Oil on canvas/242 × 361/s.d./
1543
Vienna, Kunsthistorisches
Museum
**223 Portrait of Elisabetta
Massolo Querini** (V. 234)
Lost: documented 1543
224 Tobias and the Angel
(W.I, 162)
Oil on canvas/193 × 130/
1543–4
Venice, Church of San
Marziale
225 St John the Baptist (W.I,
136)
Oil on canvas/201 × 134/
1543–4
Venice, Accademia

**CEILING OF THE
CHURCH OF SANTO
SPIRITO IN ISOLA,
VENICE**
(Nos 226A–226C)
Venice, Church of Santa
Maria della Salute

226A The Sacrifice of Isaac
(W.I, 120)
Oil on canvas/320 × 280/1544
226B Cain slaying Abel (W.I,
120)
Oil on canvas/280 × 280/1544
226C David and Goliath (W.I,
120)
Oil on canvas/280 × 280/1544

**Portrait of Pietro Aretino
(No. 246)**
*Titian painted his close friend
Pietro Aretino, famous man of
letters and art critic, in 1545.
The aggressive personality of
the 'most feared pen in Italy'
is depicted with nonchalant
brushstrokes and the massive
red costume is enlivened with
gold reflections.*

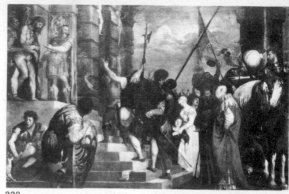

222

226A

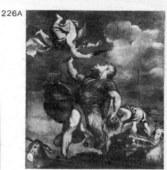

224

226B

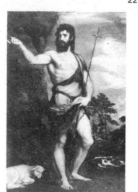

225

226C

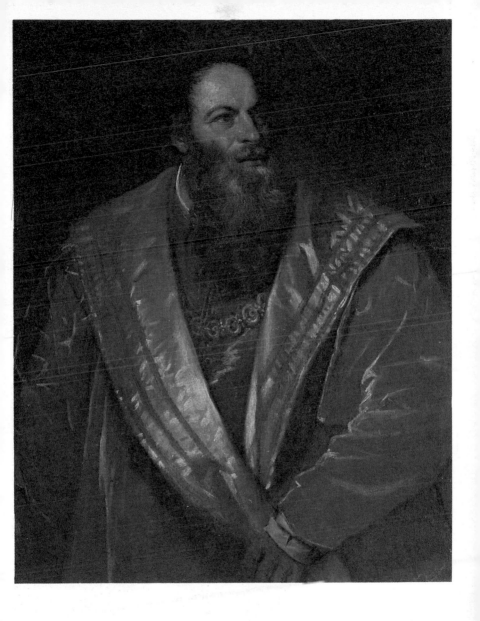

227 The Vision of St John the Evangelist (W.I, 137)
Oil on panel/237.6 × 263/
c. 1544
Washington, National
Gallery of Art

**PROCESSIONAL
STANDARD**
(Nos. 228A–228B)
Urbino, Galleria Nazionale
delle Marche

228A The Resurrection (W.I,
96)
Oil on canvas/163 × 104/1544
228B The Last Supper (W.I,
96)
Oil on canvas/163 × 104/1544
Originally the verso of the
standard

*229 Portrait of Isabella of
Portugal* (V. 242)
Lost: documented 1544
*230 Christ Crowned with
Thorns* (W.I, 82)
Oil on panel/303 × 180/s./
1544–5
Paris, Louvre
231 The Temptation of Christ
(W.I, 162)
Oil on panel/91 × 63/1544–5
Minneapolis, Institute of Arts
*232 Portrait of Daniele
Barbaro* (W.II, 8C)
Oil on canvas/83 × 70/1544–5
Ottawa, National Gallery of
Canada
*233 Portrait of Daniele
Barbaro* (W.II, 81)
Oil on canvas/81 × 69/1544–5
Madrid, Prado
*234 Portrait of Sperone
Speroni* (W.II, 140)
Oil on canvas/113 × 93/
1544–5
Treviso, Museo Civico
*235 Portrait of a Man: the
Young Englishman* (W.II,
148)
Oil on canvas/111 × 93/
1544–5
Florence, Pitti Palace
*236 Portrait of a Nobleman of
the Savorgnan Family* (W.II,
138)
Oil on canvas/124 × 94/
1544–5
Kingston Lacy, Bankes
Collection

227

228A

228B

230

231

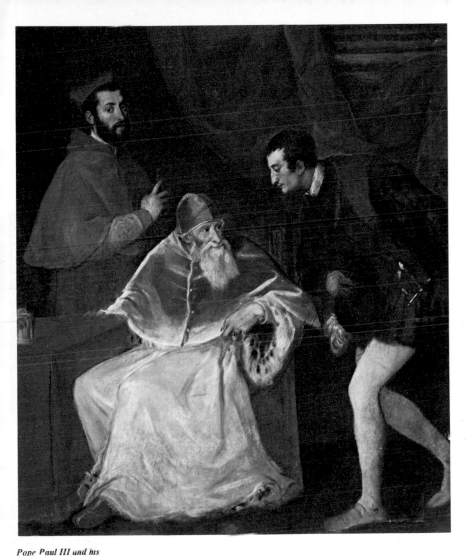

**Pope Paul III and his
Nephews Alessandro and
Ottavio Farnese (No. 250)**
*Called to Rome by the Farnese
family, Titian portrayed Paul
III with his nephews,
Alessandro and Duke Ottavio.
Titian's own strongly dramatic
temperament infuses the scene
with psychological tension.
Touches of colour create
changing reflections which are
somehow sinister.*

237 Portrait of the Doge Andrea Gritti (W.II, 108)
Oil on canvas/133.3 × 103.2/ s./1544–5
Washington, National Gallery of Art
238 Portrait of Ferdinand I (V. 252)
Lost: documented *c.* 1545
239 Portrait of Alessandro Corvino (V. 253)
Lost: documented 1545
240 Portrait of Daniele Barbaro (V. 254)
Lost: documented 1545
241 Portrait of Marcantonio Morosini (V. 255)
Lost: documented 1545
242 Portrait of Guidobaldo II (V. 257)
Lost: documented *c.* 1545
243 Portrait of Elisabetta Massolo Querini (V. 258)
Lost: documented *c.* 1545
244 Portrait of Giulia Varana (V. 263 and 595)
Lost: documented *c.* 1545. There exists a copy in Florence, Pitti Palace (Photo 244a)
245 Venus (V. 259)
Lost (letter from Titian to Charles V, 1545)
246 Portrait of Pietro Aretino (W.II, 75)
Oil on canvas/96.7 × 77.6/ 1545
Florence, Pitti Palace
247 Ecce Homo (V. 262)
Lost (Vasari, 1568: 1545–6)
248 Portrait of Pope Paul III wearing the Papal Cap (W.II, 124)
Oil on canvas/108 × 80/ 1545–6
Naples, Galleria Nazionale di Capodimonte
249 Portrait of Pope Paul III (W.II, 124)
Oil on canvas/98 × 79/1545–6
Leningrad, The Hermitage
There is a version of this painting in Vienna
250 Pope Paul III and his Nephews Alessandro and Ottavio Farnese (W.II, 125)
Oil on canvas/210 × 174/1546
Naples, Galleria Nazionale di Capodimonte

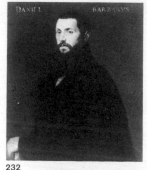

232

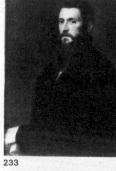

233

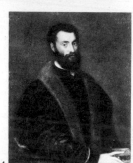

234

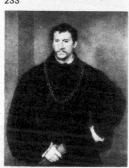

235

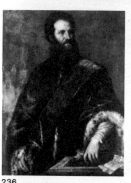

236

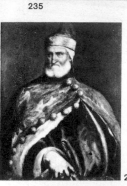

237

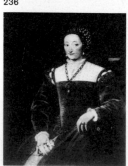

244a

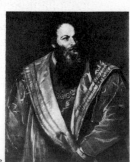

246

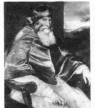

248

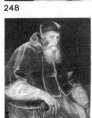

249

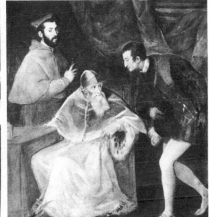

250

251

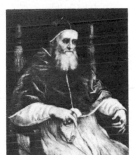

253

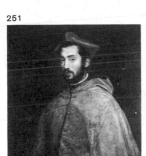

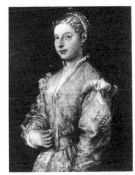

254

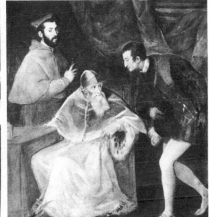

252

256

263

255

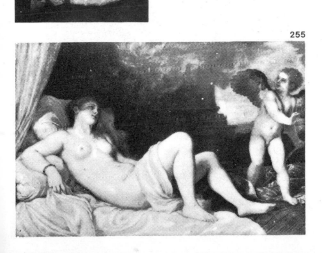

*251 Portrait of Cardinal
Alessandro Farnese* (W.II, 97)
Oil on canvas/98 × 75/1546
Naples, Galleria Nazionale di
Capodimonte
*252 Portrait of Cardinal
Pietro Bembo* (W.II, 83)
Oil on canvas/116 × 98/1546
Naples, Galleria Nazionale di
Capodimonte
*253 Portrait of Pier Luigi
Farnese in Armour* (W.II, 98)
Oil on canvas/110 × 88/1546
Naples, Galleria Nazionale di
Capodimonte
254 Portrait of Julius II
(W.II, 112)
Oil on panel/99 × 82/1546
A copy after Raphael
Florence, Pitti Palace
255 Danaë (W.III, 132)
Oil on canvas/120 × 172/1546
Naples, Galleria Nazionale di
Capodimonte
There are versions of this
painting in New York and
Chicago
256 Portrait of a Girl (W.II,
147)
Oil on canvas/84 × 75/1546
Naples, Galleria Nazionale di
Capodimonte
257 Portrait of Pietro Aretino
(V. 270)
Lost: documented 1546
*258 Portrait of Francesco
Donato* (V. 275)
Lost: documented *c.* 1546
*259 Portrait of Henry VIII of
England and his Son Edward*
(V. 279)
Lost: documented *c.* 1546
*260 Portrait of the Doge
Francesco Donato* (V. 281)
Lost: documented 1547
*261 Painting of an unidentified
subject* (V. 533)
Lost (letter from Titian to
Cardinal Alessandro Farnese,
1547)
262 Ecce Homo (V. 283)
Lost: documented 1547
263 Ecce Homo (W.I, 86)
Oil on slate/69 × 56/1547 (?)
Madrid, Prado

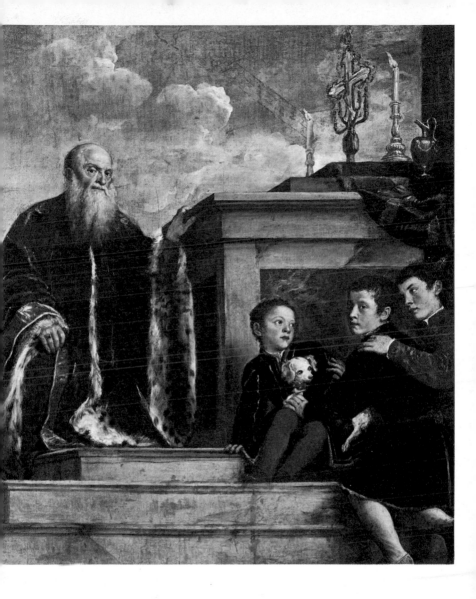

Votive Portrait of the Vendramin Family (No. 264)
*As far as can be deduced from the ages of the
various members of the family, old Gabriele, the
brothers Andrea and Lunardo with their respective
sons, this grandiose portrait of the Vendramin
family was probably painted by Titian in about
1547. Sunlight illuminates the colours with gay,
vibrant tones.*

264 Votive portrait of the Vendramin Family (W.II, 110)
Oil on canvas/206 × 301/
c. 1547
London, National Gallery
265 St John the Almsgiver
(W.I, 138)
Oil on canvas/264 × 148/
1547–8
Venice, Church of San
Giovanni Elemosinario
266 St James of Compostella
(W.I, 133)
Oil on canvas/249 × 140/
1547–8
Venice, Church of San Lio
267 Portrait of Charles V and Isabella of Portugal (V. 296)
Lost (letter from Titian to
Chancellor Granvelle, 1548).
There is a copy attributed to
Rubens in London, Sabin
Collection (Photo 267a)
268 Portrait of Ferdinand I
(V. 297)
Lost (Vasari, 1568: 1548)
269 Venus (V. 298)
Lost (letter from Titian to
Chancellor Granvelle, 1548)
270 Ecce Homo (V. 299)
Lost (letter from Titian to
Chancellor Granvelle, 1548)
271 Portrait of Marie, Queen of Hungary (V. 300)
Lost: documented 1548.
There is a copy in the Castle
of Ambras (Photo 271a)
272 Portrait of Christina of Denmark (V. 301)
Lost: documented 1548
273 Portrait of Marie Jacqueline of Baden (V. 302)
Lost: documented 1548

*Votive Portrait of the
Vendramin Family (No. 264;
detail)*
*This probably depicts the
young Federico Vendramin,
born in 1538. The contrast
between the formal costume
and the innocent
ingenuousness of the face and
pose is heightened by the use
of fine, sensitive brushstrokes.*

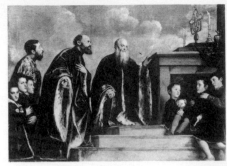

264

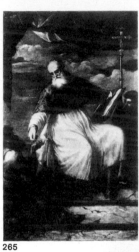

265

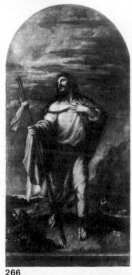

266

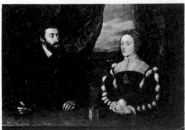

267a

271a

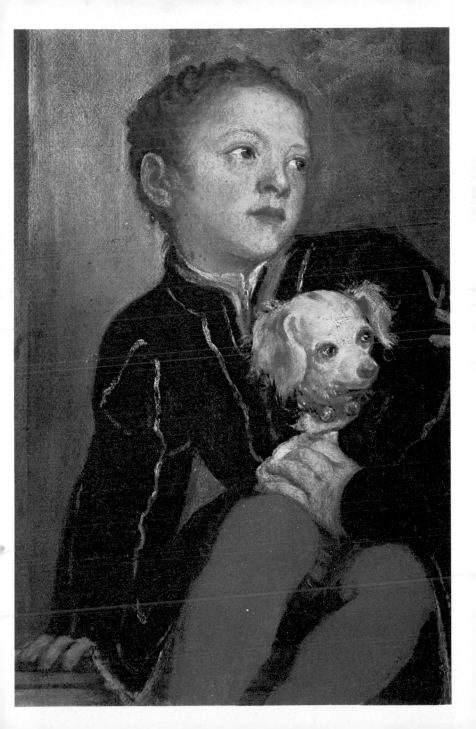

*274 Portrait of John Frederick
of Saxony in Armour* (V. 303)
Lost (Vasari, 1568: 1548).
There is a copy in Madrid,
Prado (Photo 274a)
*275 Portrait of Maurice of
Saxony* (V. 304)
Lost: documented 1548
276 Portrait of Dorothy
(V. 305)
Lost: documented 1548
*277 Portrait of Maximilian,
King of Bohemia* (V. 306)
Lost: documented 1548
*278 Portrait of Emanuele
Filiberto of Savoy* (V. 307)
Lost: documented 1548
*279 Portrait of the Archduke
Ferdinand* (V. 308)
Lost (Vasari, 1568: 1548)
*280 Four Portraits of the
Daughters of Ferdinand I*
(V. 309)
Lost (Vasari, 1568: *c.* 1548)
*281 Venus, Cupid and an
Organist* (W.III, 196)
Oil on canvas/148 × 217/s./
1548 (?)
Madrid, Prado
*282 Venus, an Organist and a
little Dog* (W.III, 199)
Oil on canvas/136 × 220/1548
(?)
Replica of No. 281
Madrid, Prado
*283 Portrait of Charles V on
Horseback* (W.II, 87)
Oil on canvas/332 × 279/1548
Madrid, Prado
*284 Portrait of Charles V
Seated* (W.II, 90)
Oil on canvas/205 × 122/1548
Munich, Alte Pinakothek

**Portrait of Charles V seated
(No. 284)**
*Called to Augsburg in 1548,
Titian made several portraits
of the emperor. The particular
merit of this one lies in its
representation of the very
human, somewhat withdrawn
quality of the figure. The
slanting light of sunset gives
an air of melancholy, which is
emphasized by the use of cold,
restrained colours.*

274a

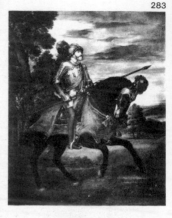
283

284

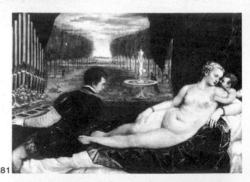
281

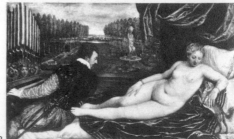
282

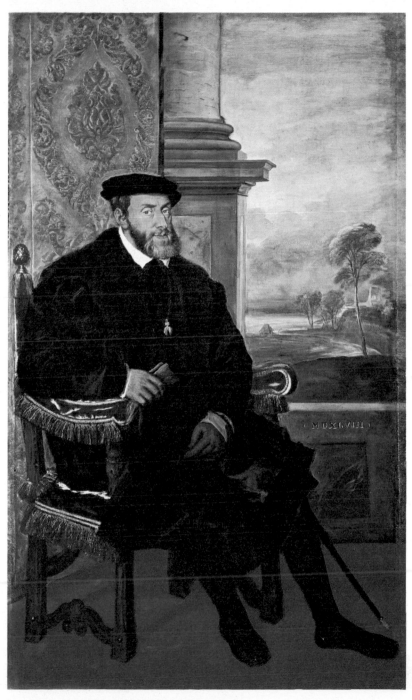

285 Portrait of Isabella of Portugal (W.II, 110)
Oil on canvas/117 × 93/1548
Madrid, Prado
286 Portrait of Giovanni da Castaldo (W.II, 84)
Oil on canvas/113.2 × 94/1548 (?)
Geneva, private collection
287 Portrait of Antonio Perrenot de Granvelle (W.II, 126)
Oil on canvas/112 × 86.5/s./ c. 1548
Kansas City, W. R. Nelson Gallery of Art and M. Atkins Museum of Fine Arts
288 Portrait of Benedetto Varchi (?) (W.II, 146)
Oil on canvas/117 × 91/s./ 1548–9
Vienna, Kunsthistorisches Museum
289 Portrait of a bearded Man (W.II, 139)
Oil on canvas/113.5 × 93.5/ 1548–9
Copenhagen, Statens Museum for Kunst
290 Portrait of a Man with Book and Staff (W.II, 99)
Oil on canvas/83 × 62/1548–9
Vienna, Kunsthistorisches Museum
291 Portrait of a Boy (W.II, 99)
Oil on canvas/89 × 67/1548–9
Vienna, Kunsthistorisches Museum
292 Portrait of Martino Pasqualigo (W.II, 121)
Oil on canvas/78.4 × 63.2/s./ 1548–9
By Titian and his workshop
Washington, Corcoran Gallery of Art

Portrait of Isabella of Portugal (No. 285)
This portrait of Isabella, wife of Charles V, was painted from other portraits, since she had died in 1539. Titian succeeds in capturing her magnificent appearance which is enhanced by the voluminous red silk and velvet dress trimmed with gold brocade.

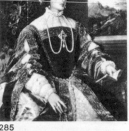

285

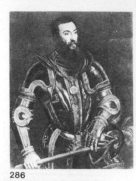

286

287

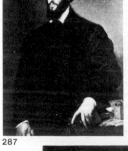

288

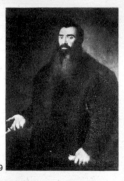

289

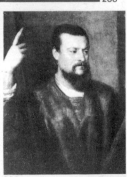

290

291

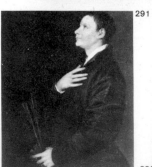

292

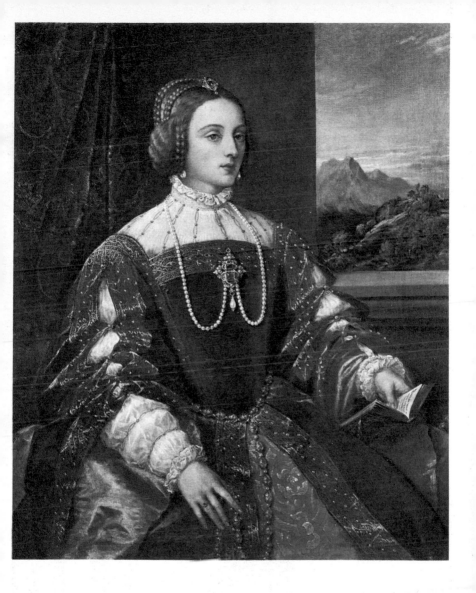

Photocredits
Scala, Antella: p. 11, 18–19, 21, 30–31, 53;
Koninklijk Museum voor Schone Kunsten, Antwerp:
p. 17; *Editoriale Gemini, Milan*: p. 29, 51, 59.

*All other colour and black and white pictures are
from the Rizzoli Photoarchives.*

See volume II for Bibliography

First published in Great Britain by Granada Publishing 1981
Frogmore, St Albans, Herts AL2 2NF

ISBN (hardback) 0 246 11297 2
ISBN (paperback) 0 586 05147 3

Printed in Italy

Granada ®
Granada Publishing ®